EMILY CARR COUNTRY

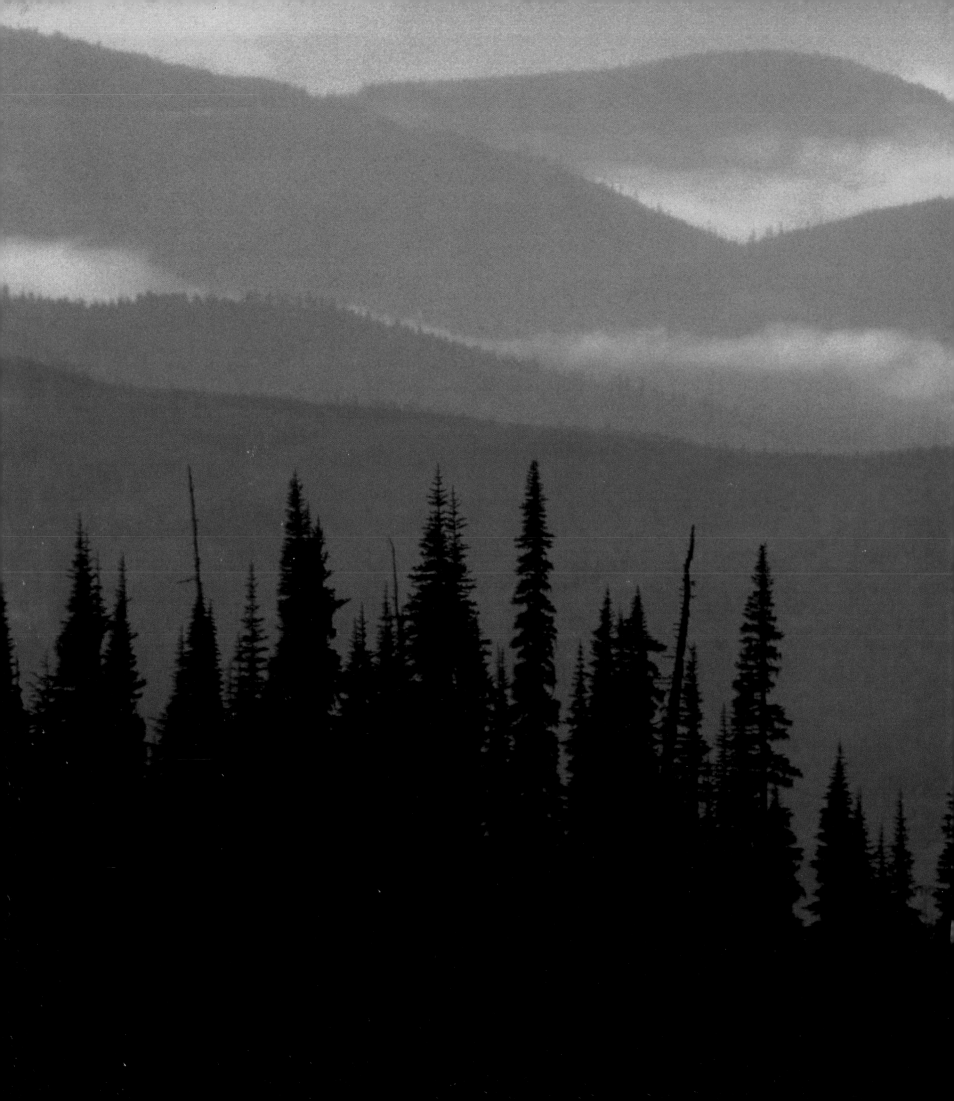

EMILY CARR COUNTRY

—————— Portrayed by ——————

COURTNEY MILNE

FOREWORD BY ROBERT BATEMAN

National Library of Canada Cataloguing in Publication Data

Milne, Courtney, 1943-
Emily Carr country

ISBN 0-7710-5889-6

1. Landscape photography – British Columbia. 2. British Columbia –
Pictorial works. 3. Carr, Emily, 1871-1945 – Quotations. 4. Milne, Courtney, 1943-
I. Carr, Emily, 1871-1945 II. Title.
FC1087. 8. M54 2001 FC3812.M54 2001 779'.36711'092 C2001-900876-7

Emily Carr paintings on pages xiv, 6, 8, 10 are reproduced by permission. Page xiv, Emily Carr, *Vanquished*, 1930,
oil on canvas, Vancouver Art Gallery, Emily Carr Trust, VAG 42.3.6 (photo: Trevor Mills); page 6, Emily Carr,
A Young Tree, 1931, oil on canvas, Vancouver Art Gallery, Emily Carr Trust, VAG 42.3.18 (photo: Trevor Mills);
page 8, Emily Carr, *Sombreness Sunlit*, 1938-1940, oil on canvas, BC Archives PDP 633; page 10, Emily Carr, *Tree
(Spiralling Upward)*, 1932-1933, oil on paper, Vancouver Art Gallery, Emily Carr Trust, VAG 42.3.63 (photo: Trevor Mills).

We acknowledge the financial support of the Government of Canada through the Book Publishing Industry
Development Program for our publishing activities. We further acknowledge the support of the Canada Council
for the Arts and the Ontario Arts Council for our publishing program.

Book design by Kong Njo

Title-page image: "Olympic Mountains," Washington, USA, 1987
Image on page 78-79: "Waves on Rocks," Botanical Beach, BC, 1998
Image on page 140-141: "Morning Fog," valley near Haines Junction, Yukon, 1983

Printed and bound in Hong Kong, China
by Book Art Inc., Toronto

McClelland & Stewart Ltd.
The Canadian Publishers
481 University Avenue
Toronto, Ontario
M5G 2E9
www.mcclelland.com

1 2 3 4 5 05 04 03 02 01

FOR MY TEACHING PARTNERS IN EMILY CARR COUNTRY

Sharron Milstein and Paul Lazarski
Pacific Rim Dimension

Adele Curtis and Manfred Forest
Soul of the Landscape, Landscapes of the Soul

Ann Mortifee
Soulscapes

Like the Beacon hill compass, you have shown me new geography to explore

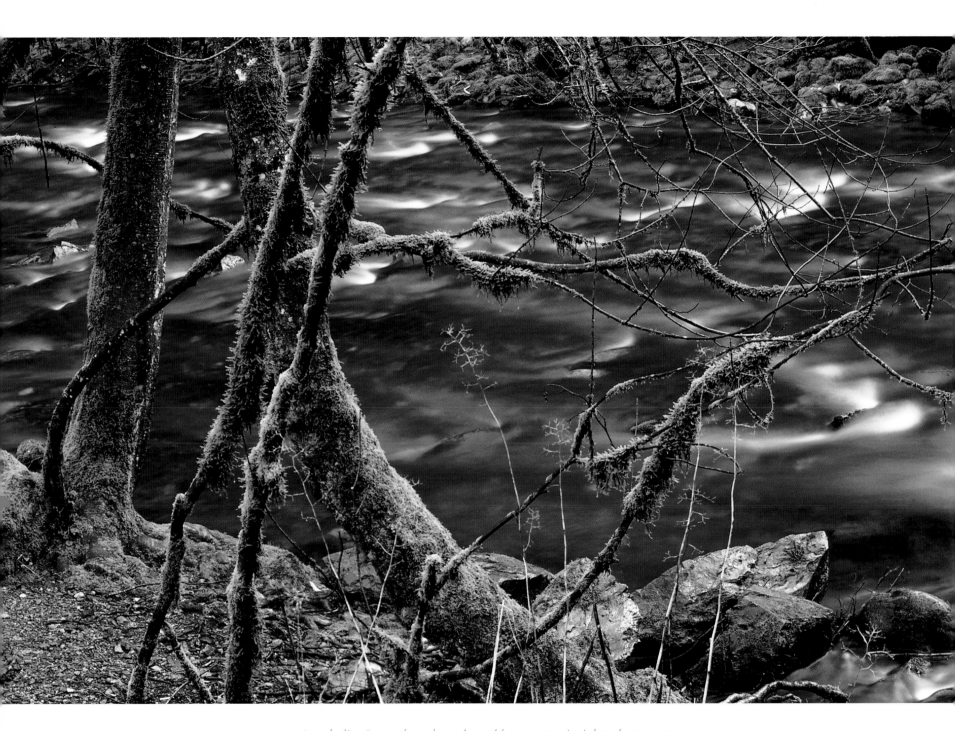

"Foreboding," moss-draped maples, Goldstream Provincial Park, BC, 1987

CONTENTS

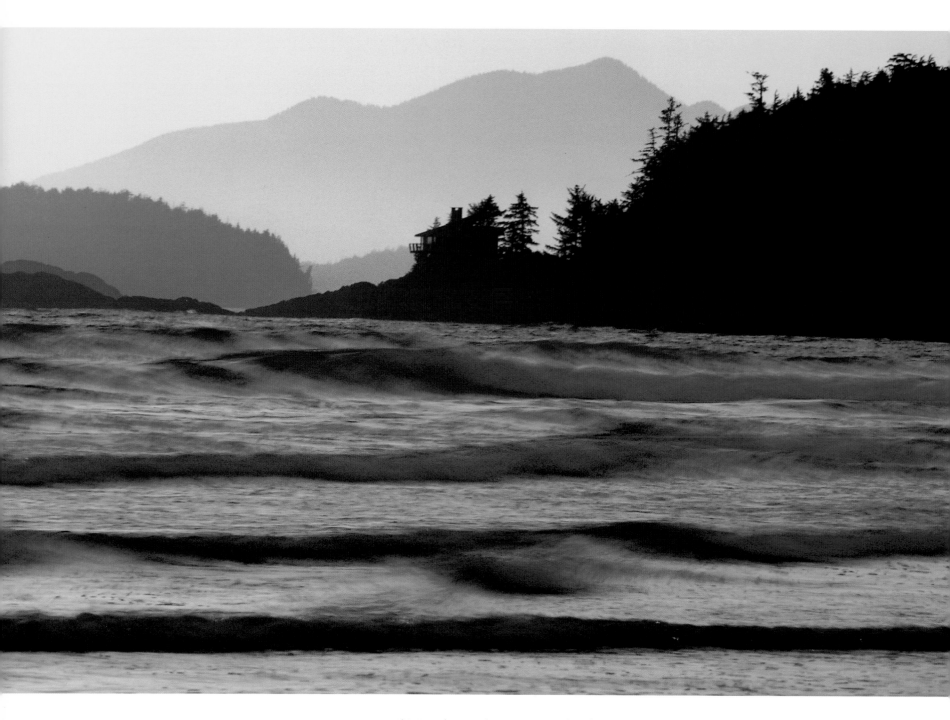

"Sunset at Wikininnish," Pacific Rim National Park, BC, 1986

ACKNOWLEDGEMENTS

Thank you firstly to Agfa Inc. for your continuing sponsorship of my work. Virtually every photograph in this book dated 1997 or later was made using RSX 100 or RSXII 100 slide film, and processed by Vistek West (formerly West Canadian Color) in Calgary. Keep up the great work, Sam! Also a big bouquet to Amplis Foto for twenty years of support, especially tripod support. My cameras have chugged through 430,000 exposures while sitting on a Manfrotto 055 tripod. And speaking of cameras, thank you to my friends at Nikon Canada for thirty years of unflagging assistance, repairs, equipment loans, and technical advice. All but the very earliest work was performed with either a Nikon F3 or F4, and my "workhorse" lens after countless years is still my Nikkor f2.8 80-200mm auto-focus zoom.

Thank you Freeman Patterson for your vision and creativity, which have so profoundly influenced my work and life. Your books continue to inspire me to extend my reach. Thank you to Fred Chapman for showing me Cariboo Country and teaching me that prairie boys can photograph coastlines too, and to Jim Allen of Ecosummer Expeditions for orchestrating my first coastline expedition – Haida Gwaii.

Thank you Robert Bateman for the inspiration of your art, your compassion for Planet Earth, and the humility and sobering reflection you exemplify in *Thinking Like a Mountain*. My times of deep love for nature and dedication to the task are Robert Bateman moments.

Thank you Adele, Garry, and David Curtis for a Victoria home and for the warmth of your hospitality and generosity. To Adele for your teaching, caring, guiding, critiquing, sharing, and proofing. There is a good big chunk of your soul in this book.

I dedicate this book to Adele and my other co-teachers because together we were so much a part of what Emily Carr stood for and believed in. I would also like to acknowledge the part that our workshop participants have played. You have broadened my awareness and deepened my appreciation for photography as a creative tool and vehicle for the soul's journey. Seeing

you connect with your inner landscapes is one of life's richest gifts. I humbly thank each of you for that. Thank you to the management and staff at Ocean Village Beach Resort and Point-No-Point Resort for accommodating our workshops.

Other citizens of Emily Carr Country have provided for and accommodated me over the years: Nancy and Bob McMinn, Sheryl and Morrie Sacks, Dorothy Miller, Sarah Bowman, Solinus Joliffe, Susie Buckley, Morgan Smith, Shari Macdonald, Corinne Allyson, Pat and Rosemary Keough, Karen and Eric Alexandre, Sherry Berkowitz, Jim Proctor, Tana Dineen, Gordon and Wilma Hartley, Carmie Verdone, Bonnie, Eric, Leif, and Karl Nygren, Margaret and Charlie Glauser, Lynda and Lloyd Powell, Michael and Jeannie Shaw, Walter and Marlene Regehr, Chris Harris, and Peter Campbell. Because of you, as well as many others, British Columbia has become my home away from home. In Victoria, thank you to the Fran Wilson Gallery, Valerie Pusey of Canadian Art Connections, and Jan Ross of the Emily Carr House for your enthusiasm, direction, and support.

Thank you to Alex Schultz, Kong Njo, Doug Gibson, and the many contributors to this book at McClelland & Stewart. Alex, your sensitivity and "deep listening" have allowed me to convey my truth without compromise, and Kong, what a pleasure to work with a master craftsman. In Saskatoon, many thanks to Randy and Laurie Ann at Chromographics for duplicating and scanning my transparencies and to Sara Gordon for putting Emily's quotes onto 4x6 cards. Thank you Philip and my friends at Cafe Casa for a place to write.

For thirteen years Sherrill Miller has managed Courtney Milne Productions. Thank you for your dedication and loyalty and keeping office and home together as I continue to photograph as though I were still young!

Thank you Karen Kingston, Samuel Sagan, William Mathis, Jeffrey Godine, Mahara Brenna, Bryan Kuss, Janis Bassingthwaighte, Larry and Rita Novakowski, Lanny Magnussen, Thomas Moore, Chuck and Lency Spezzano, Lexi Fisher, and Kip Moore for your guidance, your special gifts as healing practitioners, and your personal interest in my work.

Finally, on a spiritual note, there is recent scientific evidence that regular direct exposure to purring cats fosters health and well-being and accelerates the healing of broken bones. Thank you to Mikado, Lhasa, and Tara for keeping us healthy and contented. And thank you Emily Carr for teaching me that life's most outstanding event is not the recognition, but the *doing*. Keep challenging me with your pictures and words, and I promise not to "pickle you away as a 'done.'"

Our Zodiac sped across the grey, glassy surface of the sea towards Ninstints, the aged relic of a Haida village on Anthony Island off the southwest coast of the Queen Charlotte Islands. It was the summer of 1982, and our nature art group had visited the site a few days earlier. That had been a bright day filled with the clamour of workers' voices and chainsaws. It was not the tranquil mood we had been hoping for, but the work at Ninstints had been necessary as part of a project to rescue this United Nations Heritage Site from the biological forces that were destroying it. Four of us, including my wife, Birgit, decided to return on a misty day. It was magical. Suddenly our Zodiac was surrounded by Pacific white-sided dolphins leaping beside us and in front of us. Birgit, who was trying to photograph them, was pre-focusing on the spot in front of us where a dolphin might emerge, when a fin and a back began to appear a couple of metres in front of us. It got bigger and bigger. We cut the motor as the back of a huge fin whale appeared. In the astonished silence, all of the dolphins disappeared and we wondered if we had been seeing things. Then the great beast paid us one more close visit. As it rolled we looked into its eye almost beside our pontoon. It broke the surface and blew spray (and hali-tosis, one of its calling cards) all over us. After minutes of transfigured silence, we continued on to Ninstints. The clean-up crews had left, and we were alone with those wooden totems in the quiet and the mist.

Courtney Milne should have been with us. We had met him just days before as he had finished his photography workshop and I was starting my drawing and painting one. Unfortunately, he could not join us, but that day, one of the most memorable of my life, was a Courtney Milne day in a Courtney Milne place.

I consider Ninstints one of the four or five most spiritual places I have ever visited, and the spirituality of a place is central to Courtney's work and, in fact, his life. His photographs take us into realms beneath, and in a sense above, the literal surface of locations that have

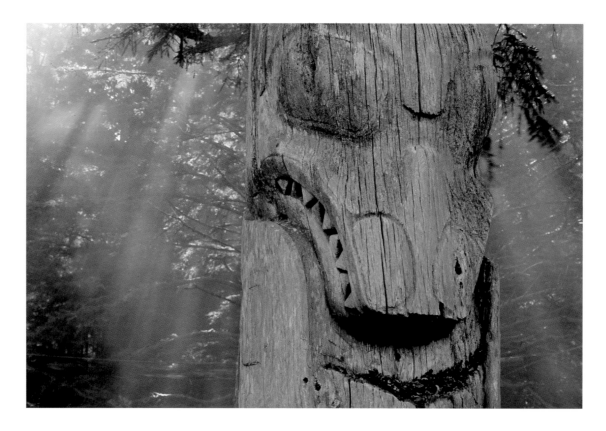

"Totem Spirit," Ninstints, Haida Gwaii, BC, 1982

become, in many cases, merely ticks on a tourist's checklist. Birgit and I have been lucky enough to visit many of the places Courtney has photographed, and I admit that often I can be too caught up in my sketchbook or camera lens to really see and really feel the profound qualities of the place.

In the paintings of Emily Carr there is a similar attribute that goes beyond the surface plane. It is this deeper force that drives the work of both Carr and Milne. They both start with nature and go beyond it, even distorting it to help express its qualities.

To plumb the full importance of the legacy of Emily Carr, however, it is necessary to read her eloquent and heartfelt words. The same applies to the work of Courtney Milne. In this book he brings us a generous serving of Carr's words, but his own words are also worth savouring and pondering. Reading the words of both Carr and Milne has changed my perception for the better. It could change yours too.

Of all the thought-provoking quotes from Carr in this book, there is one I must comment upon. She says ". . . nor could ten million cameras through their mechanical boxes ever show

real Canada. It had to be sensed, passed through live minds, sensed and loved." We have to look at this statement in the context of Carr's place in the history of photography and art. The cameras and tripods used at the beginning of the twentieth century were large, heavy, and cumbersome to pack around, and thus restricted the photographer to a rather conventional treatment of his subject. The lightweight and highly portable single-lens reflex camera, which allows the photographer to compose through the lens, was not introduced until twenty years after Carr's death, just as Milne was beginning to record his vision on film. Had Emily Carr seen what could be done with interchangeable lenses, viewpoint, and selective focus, she too might have picked up the camera as a creative tool.

Also, in Carr's day, the nineteenth century photographic look to painting was beginning to be seen as inadequate. Since a camera could capture an image, why bother painting it? The painter's expressive departures from nature had to convey a deeper meaning. This is no longer the prevailing view. Not only is photo-realist painting accepted in art museums, but photography exhibits sometimes outweigh the painting exhibits on the walls. That photography is a valid art form is no longer in question. In fact, to my way of thinking, many photographers are far more creative and perceptive than most painters. Photography and film-making can help us to explore the world of nature, God's creations if you like, in a far more intricate and profound way than centuries of drawing and painting. Milne's art through the camera lens excels in this category of creative exploration.

I have been on many trips in many beautiful parts of the world, often with groups. There is almost always at least one person in the group who feels that a camera gets in the way. For them, it forms a blockage between the individual and the piece of the planet they are there to appreciate. I take the opposite view. Most serious photographers are very engaged with the place, both in detail and in the big picture.

Courtney Milne is not only engaged with the surfaces and the textures of the worlds he explores, he seeks to reveal the realm of the soul and the spirit. And so does Emily Carr. Viewing the pictures in this book will be a happy journey for the eyes. Reading the words of these two artists will bring a new perspective to Milne's imagery.

ROBERT BATEMAN,
Saltspring Island, B.C.

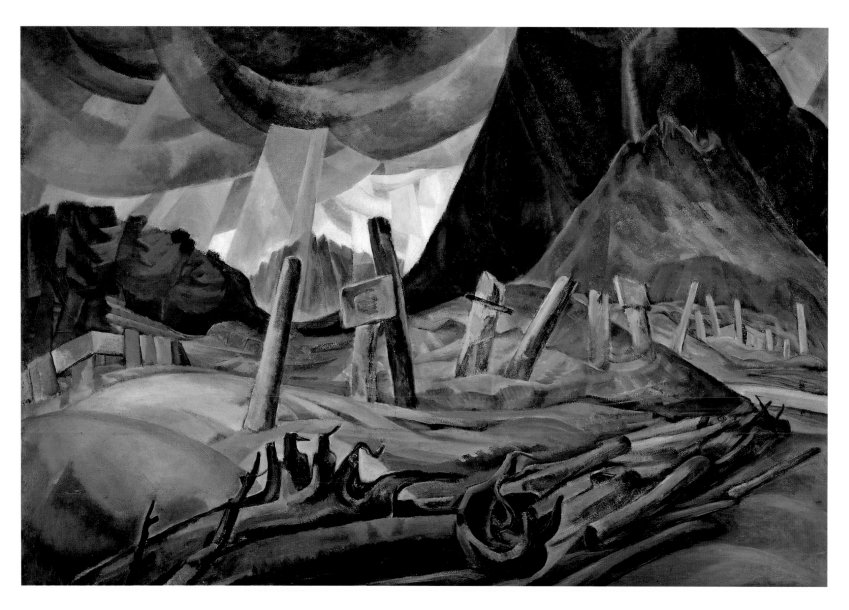

"Vanquished," oil on canvas, Emily Carr, 1930

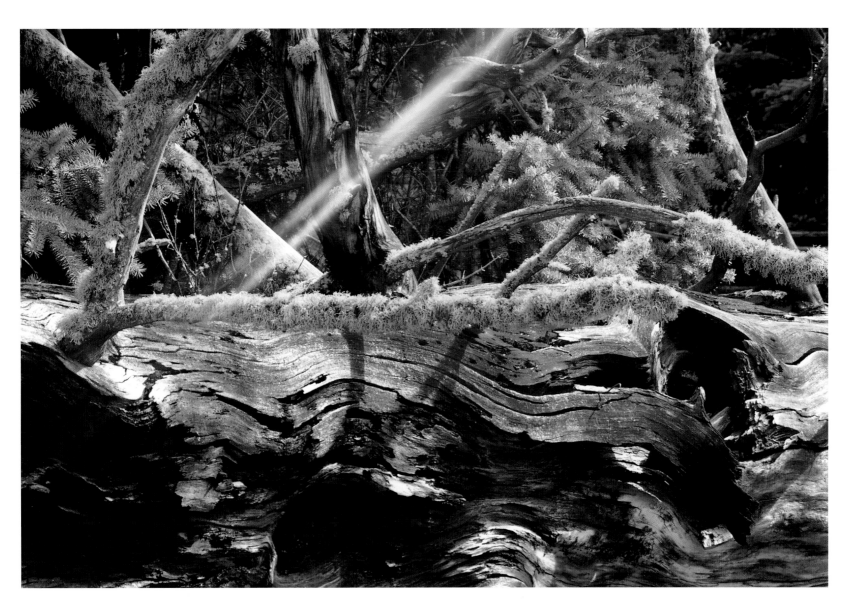

"Weathered Deadfall," Cariboo Country, BC, 1984

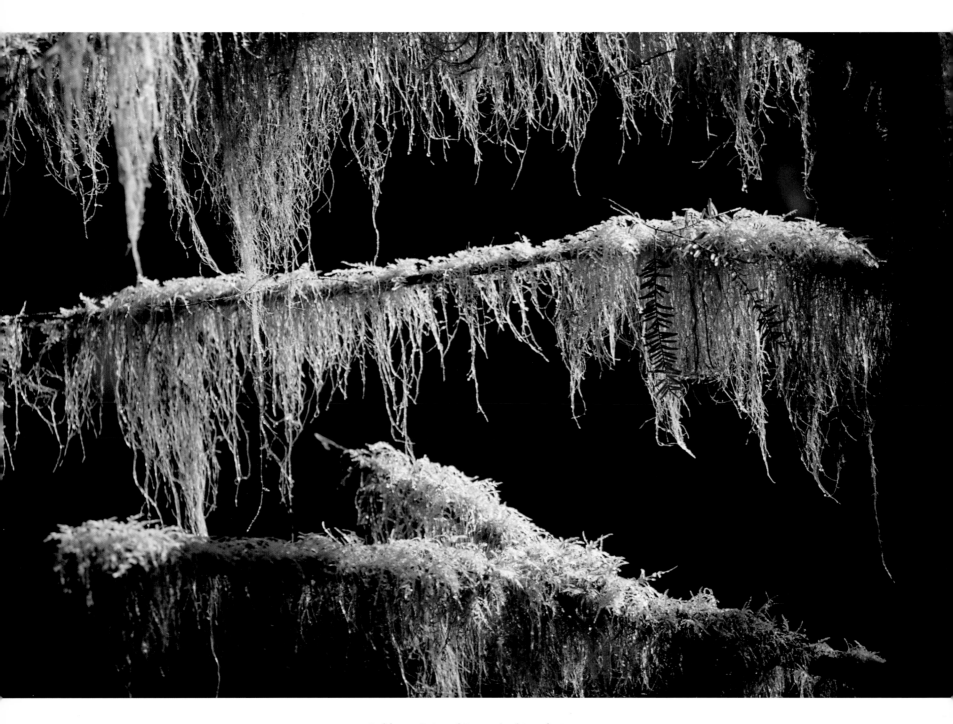

"Old Man's Beard," Botanical Beach, BC, 2000

"The Tremendous Elsewhere that Lies Behind"

"Casually, you would think the world very still this morn, but really, when you consciously use your ears, there's quite a bustle and stir. One is so lazy about life, about using our senses. It is easier to jump into the luxurious vehicle called Drift and go nowhere particular, then wonder why we don't get anywhere. There's smells — they have to fairly knock us over before we heed them. They are such a delicate joy, and we miss three-quarters of it because we don't tune our noses in. Fussy enough about taste because our stomachs are so demanding, we take sight for granted and only half use it, skimming along the surface. Nor do we listen in to the silence and note all the little, wee noises like the breezes and insects. Good heavens, the row there'd be if you could hear the footfall of all the ants! And then there's feel. We don't get one one-hundredth what we should out of feels. What do we bother about the feel, the textures of things alive, and things made, and things soft, and hard, cold and hot, smooth and rough, brittle and tough, the tickle of insects, the touch of flesh, the exquisite texture of flower petals, the wind's touch, the feel of water, sleep pressing our eyelids shut? We accept all these things, that could so immeasurably add to our life, as a matter of course, without a thought, like animals do. In fact animals seem to get more out of their senses than many people, yet we are supposed to have minds and they not."

HUNDREDS AND THOUSANDS

My photographic adventure into Emily Carr Country has spanned twenty years of trips by foot, automobile, bus, train, kayak, dugout canoe, Zodiac, ferry, horseback, helicopter, seaplane, camper, 4-wheel drive, bicycle, chairlift, and cable car. Because I conducted photography workshops for five years near Tofino and four years near Sooke, I have had the pleasure of discovering special places and being able to visit them again and again, watching them transform over time. Surely, it was this everchanging nature of the Pacific Northwest, both awesome and subtle, seasonal and daily, through tumultuous outbursts and periods of silence that kept Emily Carr so fascinated, vigilant, absorbed, even mesmerized. She was in love with her beloved land, and over time I have begun to learn why. One of my favourite examples of transformation in nature is a sea cave at the south end of Botanical Beach, accessible only at low tide and highly dangerous when the surf is up. I call it "Hummingbird Cave" because of the distinctive shape the sea has carved into the rock wall (see pages 84 and 85). At the time

of my first visit, the cave was light and welcoming. Two years later, I could hardly believe it was the same place. The walls had turned from pastel blues and greens to brown. Instead of nurturing, the cave now felt threatening. The soft, moist rainbow kelp that had graced the floor had been invaded by ramrods of timber washed in by a winter storm and strewn about the opening, making the entrance almost impassable.

As I, too, have fallen in love with these untamed places, with the rhythms of the sea and the haunting grandeur of Emily's "tabernacle woods," I have come to realize that Emily Carr Country is so much more than the sum of my experiences there. It is the way that she senses, feels, describes, and portrays the divinity of all living things that has so profoundly affected me. For two decades, her journals have inspired me and her paintings have enriched my eye. Her art keeps prodding me to return to the source, to the places raw and unkempt, like fissures seeping primordial energy, teasing and taunting me to peer further into the heart of mystery. Emily wasn't easily satisfied, and neither am I. When I am out with the camera, I photograph with all of my senses, but all too often it doesn't feel like enough. Emily gives me the pluck to keep trying, to resist taking the easy way out. Her tenacity and unwavering clarity of vision lift my heart, give purpose to my soul, and provide solace when I feel I have come up short. The more I learn of her life and her struggle, the more I respect her legacy.

Though I have no desire to imitate her style or copy her designs with a camera, I do take a delight in noting how sometimes a similar mood or visual effect seems to be present in my work. Occasionally, I will deliberately allow sun flare on the lens to form an integral part of the composition, something normally considered a mistake in photography. Some of these images bear a striking resemblance to Carr's employment of shafts of light to express an ethereal presence (see page xiv). Another technique I enjoy is to record a number of exposures on the same frame of film. It is a way of focusing attention on the quality and shimmer of light, rather than on form. By diminishing shape and making it a less dominant element, I can portray the universal forest rather than a specific one. Similarly, when I purposefully move the camera during an exposure, the actual shapes and details of the trees are obscured and the resulting image conveys more about my impression, and less about documenting the scene.

Emily Carr Country is about my pursuit and how it evolved. It began for me as a way of reaching beyond my "little house on the Prairies," going beyond the familiar and the

comfortable, discovering new territory with my camera. Over the years, the quest has led me to discover more of my own inner geography. As I have continued to explore the landscape, Emily Carr has been having her way with me. She has altered my perception, resulting in changes to my camera technique, not to mention upsetting my entire hierarchy of values and priorities. Instead of exploring simply with camera and tripod, I would add a copy of *Hundreds and Thousands*, Carr's published journals, to my camera bag. I progressed to carrying my favourite entries on index cards so that they were more accessible on my outings.

Instead of asking myself, "What should I photograph today?" I found myself pondering, "Why is this woman so important to me?" Some of the answers came merely by shuffling through the cards, and letting them, like a tarot reading, provide me with answers. What came to me overwhelmingly as I sat one morning waiting for my mushroom omelette in a small cafe in Clinton, B.C., was that Emily Carr somehow managed to maintain herself in a place of authenticity. Her responses to the world came not from the head but from the heart, and she embraced her love for the untamed landscape with a flood of passion. Her passion was not painting; she developed the necessary skills over the years, but she always found it hard work. Nor was it writing, for only in her late fifties did she begin her journal, and though she received the Governor General's award for her book *Klee Wyck* in 1941, she never wrote with complete confidence. What she did have was a heavy dose of tenacity that gave her the grit to portray her truth. She had volumes that she wanted to say – with her paintbrush and her pen. She persevered because she couldn't imagine doing anything else. She persevered because, above all else, she felt such an affinity with the ebb and flow of the sea, the hush of the forest, the bigness of the mountains. These realities were so salient for her that she simply had to respond to them. And so she painted, and got very good. And she wrote, and developed her own style as she had done with watercolours and oils.

The odds of success were infinitesimally small. She was a woman, living in the frontier world of Western Canada, and was almost thirty years old at the dawn of the twentieth century. By then she should have been married, had a clutch of children, supported her husband's career, attended garden parties, contributed to charities, looked nice, acted politely, and kept out of trouble. Her painting should have been a pleasant pastime, certainly not a career.

Instead, she pursued her passion — to live in wild places and to live an honest, genuine, real life in the raw, striving to find the divinity in all living things, and just maybe finding a way to express it.

That's what I realized as I sat there, staring at my index cards at breakfast that morning in Clinton, spearing the mushrooms from my otherwise bland omelette and savouring their wild succulent flavour. Once you are clear on your priorities, there's always a way to home in on them. Emily got that figured out at an early age, and as far as I can discern she almost never wavered. She claims that after the Provincial Archives turned down a major purchase of her work, she let a dozen years slip by without painting. In fact, she did do some, but her priority during those lean times was, and had to be, nothing short of survival, not painting. She lived true to herself, true to the part of herself that made her purpose clear and big — big enough that other, lesser, competitors for her attention, including a suitor, dropped away.

The consequences of her choices were many. She was often misunderstood, marginalized by the art community for many years, and scorned by her sisters for much of her life. Only in her dying days did she allow herself to put her suspicions aside to receive some well-deserved recognition for her art. Even though she had several close friends, she felt alone in the world save for her animals, and shunned by the society that had admired her pluck when she was young. And as if that weren't enough, she was forced to perform the most menial of chores as landlady and scrubwoman for her subsistence. The omelette in her life was all over the floor and there was often much egg on her face, yet somehow she plucked out those wild mushrooms and turned them into magic.

It's time now to embark on what for me has been an extraordinary adventure, the journey into Emily Carr Country, and maybe into that indescribable place somewhere deep within it that Emily once called "the tremendous elsewhere that lies behind."

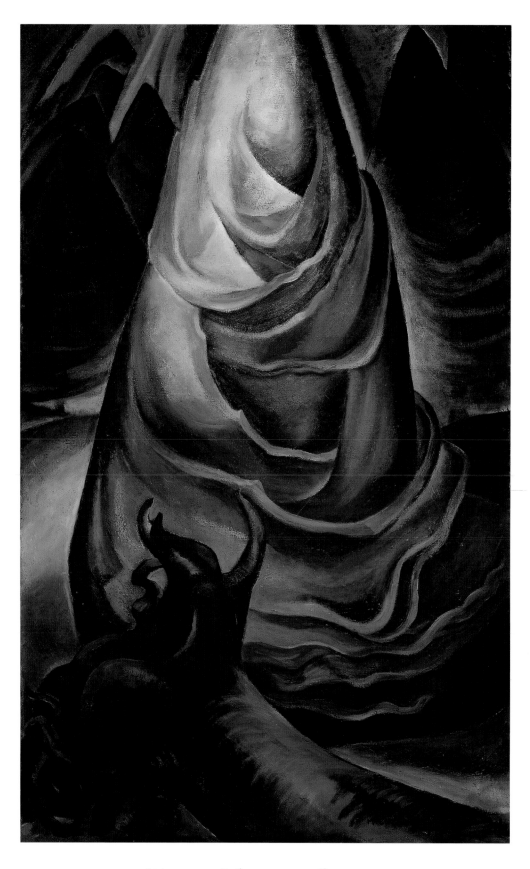

"A Young Tree," oil on canvas, Emily Carr, 1931

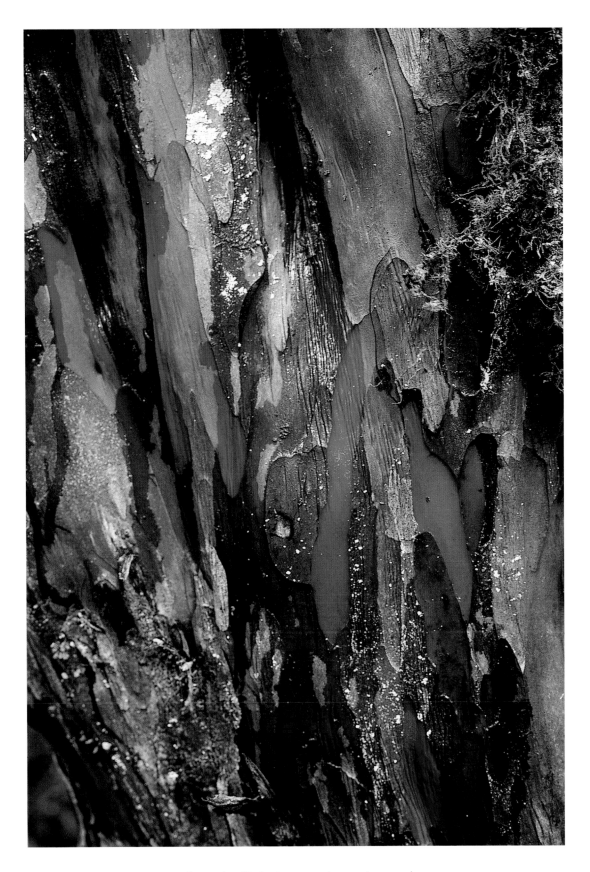

"Heartbeat," detail of rain on ponderosa pine trunk, 1984

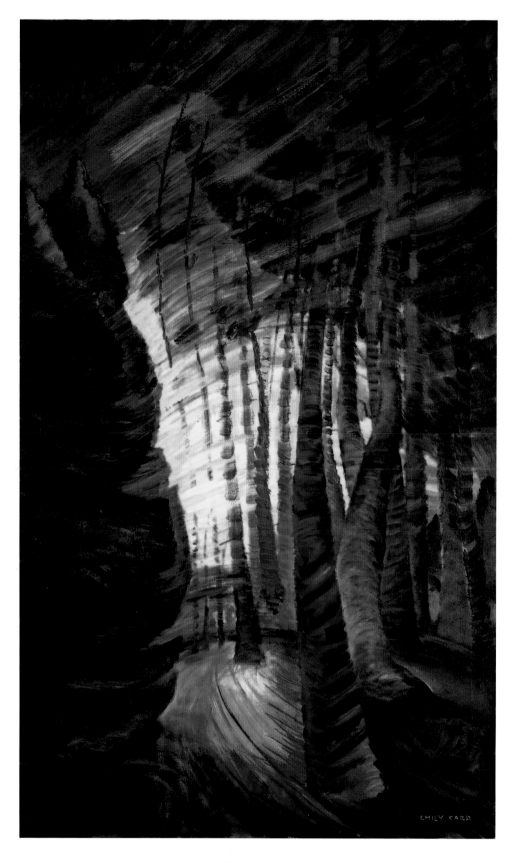

"Sombreness Sunlit," oil on canvas, Emily Carr, c.1937-40

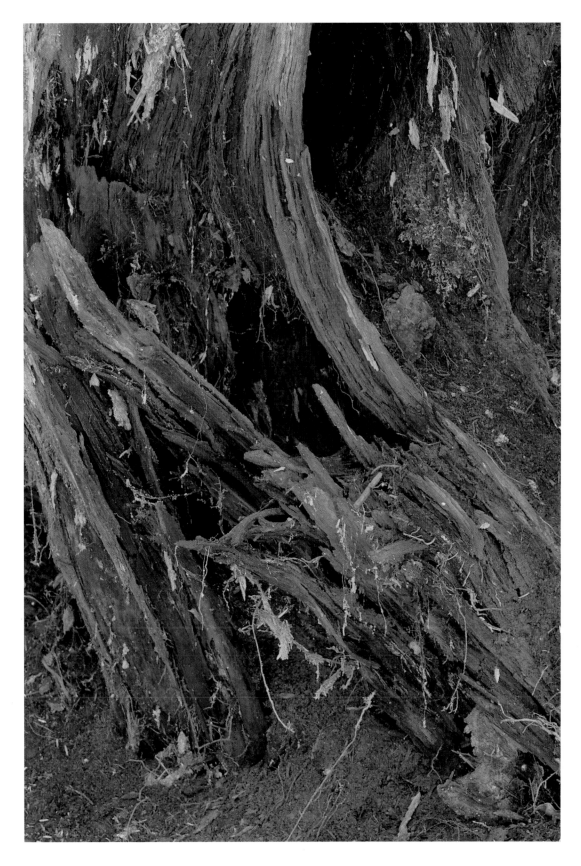

"Evening Light," detail of western red cedar bark with lichen, 1986

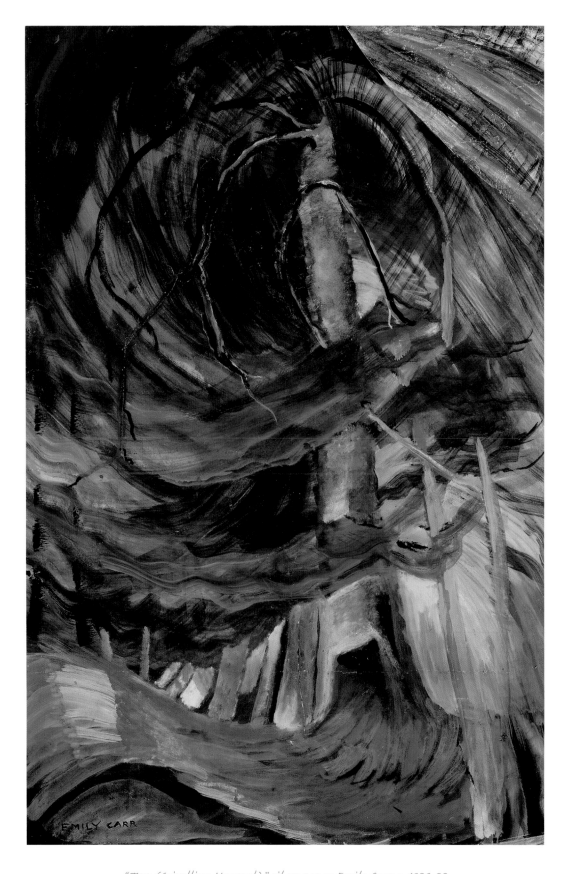

"Tree (Spiralling Upward)," oil on paper, Emily Carr, c.1932-33

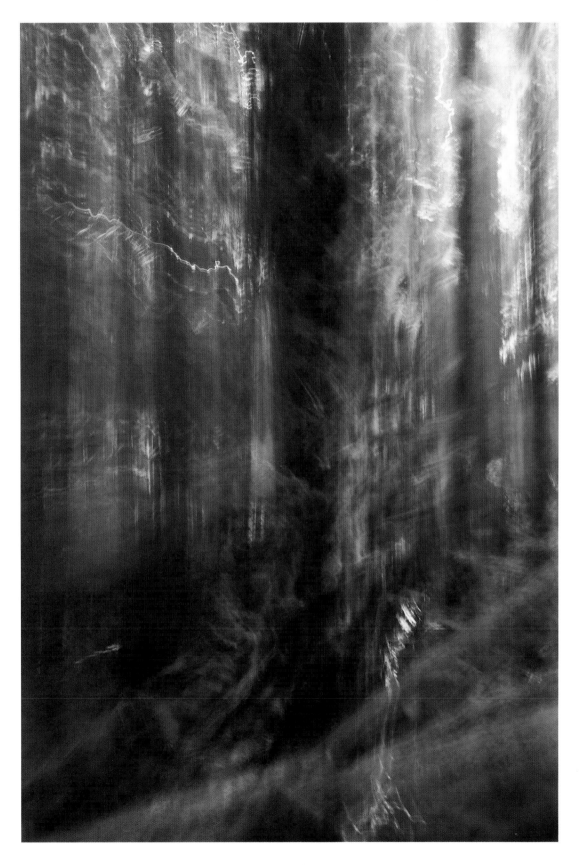

"Nirvana," handheld zoom on cedar and fir trees, 1997

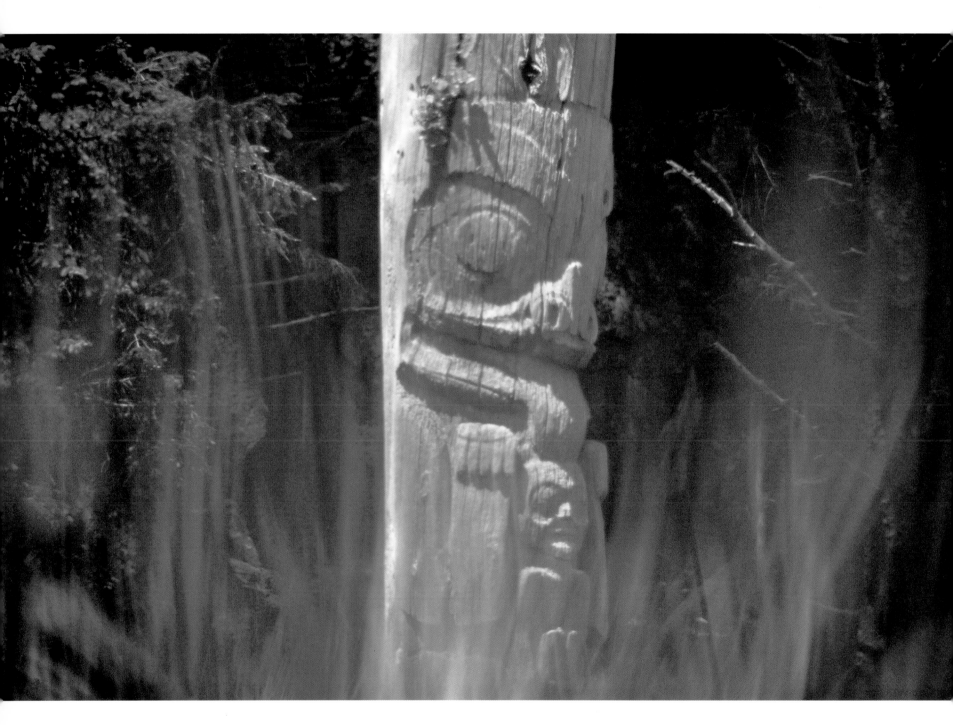

"Through the Grasses," Ninstints, Anthony Island, Haida Gwaii, BC, 1982

A Taste for Distant Shores

HAIDA GWAII

"More than ever was I convinced that the old way of seeing was inadequate to express this big country of ours, her depth, her height, her unbounded wideness, silences too strong to be broken — nor could ten million cameras, through their mechanical boxes, ever show real Canada. It had to be sensed, passed through live minds, sensed and loved."

GROWING PAINS

Haida Gwaii. The very name sent shivers through me. Much more haunting and alluring than its present anglicized name, Queen Charlotte Islands. In 1981, on the day the phone rang with an invitation to lead a photography expedition, I knew nothing of the Charlottes, only having a rough idea of where to locate them on a map, and nothing of Emily Carr's love affair with the rugged coastline of British Columbia.

Only on my return from the Charlottes would I see Emily Carr's original oil paintings in the Vancouver Art Gallery and at the same time pick up a copy of *Hundreds and Thousands*, her published journals. And only much later, long after her spiritual influence on me had taken deep root, did I begin to follow her travels or plot her destinations. Little did I know that far removed from the mainstream of commercial development, Haida Gwaii was an exotic archipelago that had harboured Native settlements along its coastline for virtually thousands of years. So secluded and isolated were these fishing villages that when Emily Carr began to visit them in 1907 and depict them in watercolour,

she was one of the first people ever to do so. Quite an amazing feat, considering the courage it must have taken to venture into uncharted waters alone, and considering the taboo it was for women of the time either to travel unescorted or, for that matter, to treat their art as a serious pursuit. Her goal was to paint the totem villages of Haida Gwaii, the Skeena River, and the Gulf Islands. For several years she continued, virtually alone in this quest, mainly because she felt passionately that these monuments and settlements needed to be documented for posterity. Her self-imposed mandate was to paint "every Haida and Kwakiutl totem in existence."

When Vancouver-based Ecosummer Expeditions phoned me to ask if I would come and teach and photograph in this wild and primitive corner of Canada, the decision was an exceedingly easy one. Easier still when I learned that the art excursion would be one of four offered that year, the others featuring respectively Robert Bateman, Freeman Patterson, and Fred Chapman, all highly accomplished artists whom I knew and greatly admired. The offer to stay in the Charlottes and attend Bateman's painting workshop following mine was the icing on the cake, though as it later turned out, a space was not available.

Looking back twenty years, I realize that even then, in the early days of my adventures with the camera, I acted much more from the heart than the head, from an inner knowledge that to say "yes" would put everything right. That is one of the essential ingredients both in the pursuit of art and in one's love for nature. And that is what attracted me to Emily Carr, the person, the writer, and the painter. It was her allowing the unafraid, curious, robust, adventurous spirit within her to have expression, regardless of the consequences, that gave her the power to pursue and endure over her lengthy and tumultuous career.

A wave of excitement tinged with anxiety swept over me as I boarded the plane in Saskatoon to begin my journey to Sandspit. Both the teaching on location and the location itself were new for me, but the anticipation of connecting with the spirit of Haida Gwaii far outweighed any impulse to turn back. And looking back I see how comfortable and easy my excursion really was compared to Emily Carr's travels. Her Haida guide, Jim, communicated in very few words and thought nothing of roughing it. My guide, Jim Allen, was the manager of a travel company that catered to the needs and special interests of a large-cross section of clients. Emily's accommodation was often a

"Cliff Face," Moresby Island, Haida Gwaii, BC, 1982

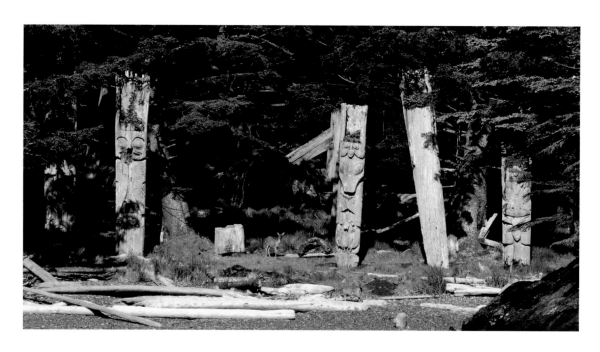

"Arrival," totems at Ninstints, Anthony Island, Haida Gwaii, BC, 1982

shanty, vacant because no one else wanted to live there. My home at Fanny Bay for a week was a spacious wall tent, with a comfortable cot off the ground, and gourmet cooking served in the mess tent a thirty-second stroll from my front door. Our itinerary included outings in two large Zodiacs capable of handling rough waters and rocky landings, and always close enough to each other to be of assistance in an emergency. Each day we explored the coastline of southern Moresby Island and took hikes, camera gear in tow, to wild and exotic places dripping with ancient mystery. Moss hung from the trees like the long dishevelled beards of a thousand gnomes cleverly disguised amongst the branches. Sea lions frolicked on the rocks offshore, then surfed the rolling breakers at high tide. Small streams gurgled and whispered and beckoned to be photographed, especially when they eased themselves lazily into a reflecting pool or slid gently over colourful stones glistening in the mid-afternoon light. Giant cedar and Douglas fir towered above us, reached mightily for the heavens, yet were firmly anchored in the soil made rich by a thousand years of decay – wood, shell, flesh and bone, forebears of the Haida ancestor spirits that made this land their enchanted domain.

All of nature was pleasured by the daily rains. The sky gods seemed almost predictable in their orchestration of events – morning fog burned off by ten, blue sky,

sometimes quite fleeting, then afternoon build-up of cloud that poured out its contents around teatime, the evenings cold and damp but cozy around a campfire complete with guitars and ukulele. The rains never dampened our spirits or the daily program, because there was so much to photograph, the vegetation all the more verdant and fresh.

The highlight for me was Ninstints, on Anthony Island, an old Haida village given the status of World Heritage Site by UNESCO not long before our arrival. The most striking feature was a magnificent row of mortuary poles still standing above the high-water line along the beach. As our dinghy rounded the point a short distance away, the totem poles came into view, their weathered skin reflected in the glassy waters of the bay, while two deer posed majestically in front. We had the cameras concealed to protect them from sea spray, and so missed getting this initial greeting on film. "Back up," I shouted to Jim over the drone of the engine as he was starting to throttle down. A chorus from the others echoed my request. He angled the dinghy into an arc and slowly retraced our path, this time with shutters clicking merrily, and the motor barely pushing us forward. The deer looked up, no doubt perplexed by all the fuss, then ambled away. Once ashore we realized we had landed on a team of anthropologists and workcrew busy felling trees around the totems to allow in more sunlight to dry out the rotting timbers. Though the motive seemed noble enough, the fractious buzzing of the chainsaws broke any magic we had hoped to find here. We recorded a few shots of the poles in the harsh sunlight, then retreated from the noise to explore the island. Upon our return a couple of hours later, I was delighted to find they had set the slash ablaze, creating an ethereal blue haze that drifted and floated dreamily amongst the totems. The smoke appeared as tangible evidence of the spirit world that pervaded this sacred place. The next hour was one of the most joyous sessions I have ever experienced photographing, and a poignant reminder not to judge a place by first appearances.

Whenever I am reminded of Emily's dismissal of the camera as a means of expressing the mystical, I smile and invite her soul to accompany me on the beach at Ninstints and revel in the mystery of these ancient monuments . . . and, yes, perhaps even take an occasional squint through the viewfinder of one of those "mechanical boxes."

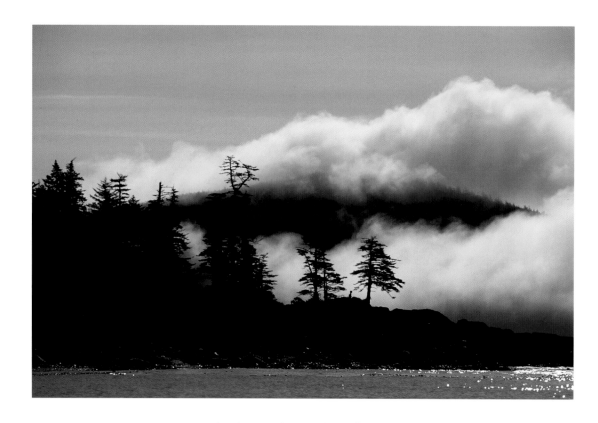

In the late afternoon, Jimmie shut off the engine and said, "Listen." Then we heard a terrific pounding and roaring. It was the surf-beat on the west coast of Queen Charlotte Islands. Every minute it got louder as we came nearer to the mouth of the Inlet. It was as if you were coming into the jaws of something too big and awful even to have a name. It never quite got us, because we turned in to Cha-atl, just before we came to the corner, so we did not see the awfulness of the roaring ocean. Seamen say this is one of the worst waters in the world and one of the most wicked coasts.

KLEE WYCK

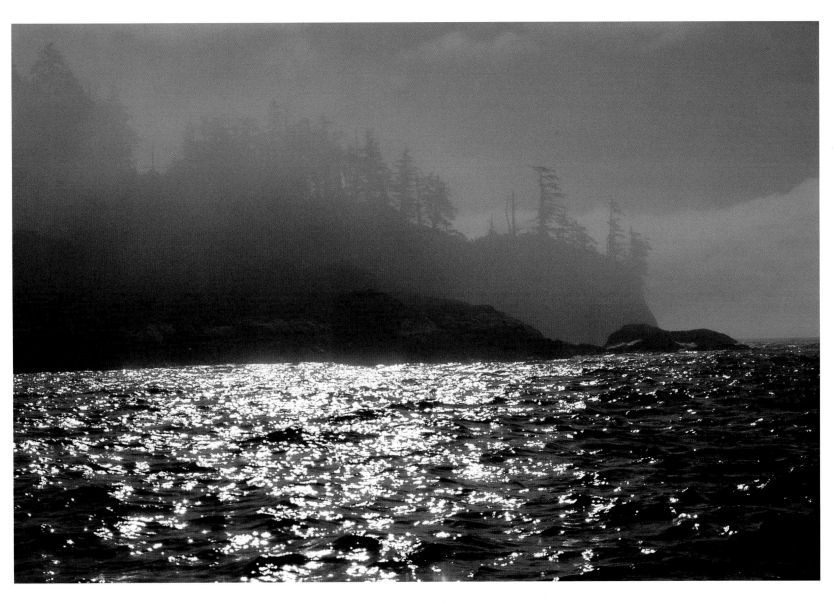

"Burning Off," Moresby Island, Haida Gwaii, BC, 1982

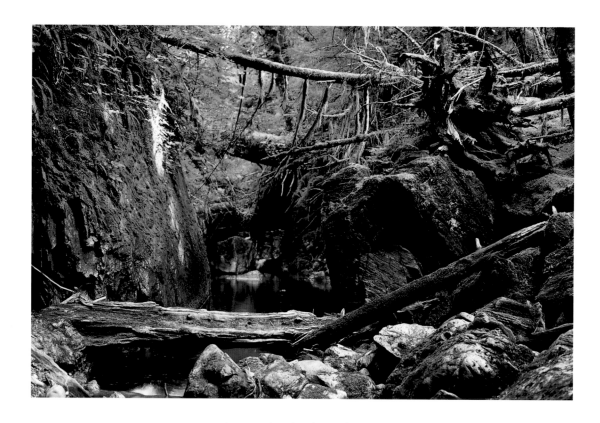

"Stream Bed," Moresby Island, Haida Gwaii, BC, 1982

Sketched in the big old wood. Trees old-fashioned, broad-spreading and nobly moulded, beyond cutting age. There is no undergrowth in that wood, only old fallen branches and wild grass, but mostly moss, very deep and silent, sponging down many old secrets.

HUNDREDS AND THOUSANDS

"Detail of Cliff Face," Moresby Island, Haida Gwaii, BC, 1982

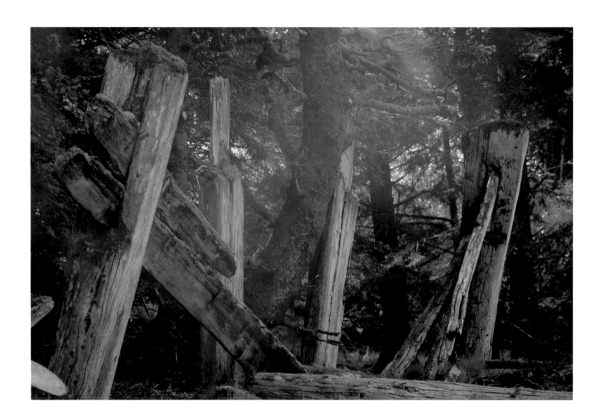

"Fallen," remains of dwelling, Anthony Island, Haida Gwaii, BC, 1982

It was so still and solemn . . . it would have seemed irreverent to speak aloud; it was as if everything were waiting and holding its breath. The dog felt it too; he stood with cocked ears, trembling. When the others came and moved about and spoke this feeling went away.

At one side . . . rose a big bluff, black now that the sun was behind it. It is said that the bluff is haunted. At its foot was the skeleton of a house; all that was left of it was the great beams and the corner posts and two carved poles one at each end of it. Inside, where the people used to live, was stuffed with elderberry bushes, scrub trees and fireweed. In that part of the village no other houses were left, but there were lots of totem poles sticking up.

KLEE WYCK

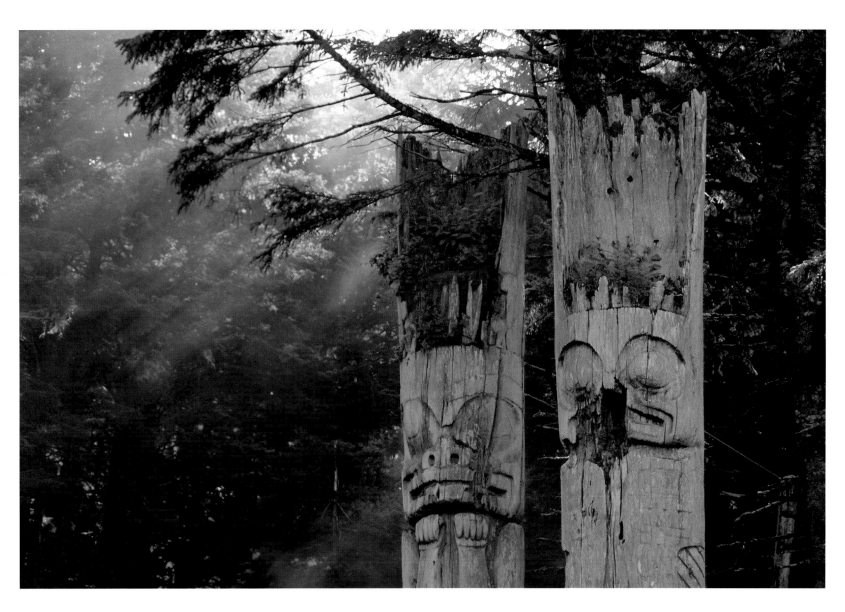

"Haunted," Ninstints, Anthony Island, Haida Gwaii, BC, 1982

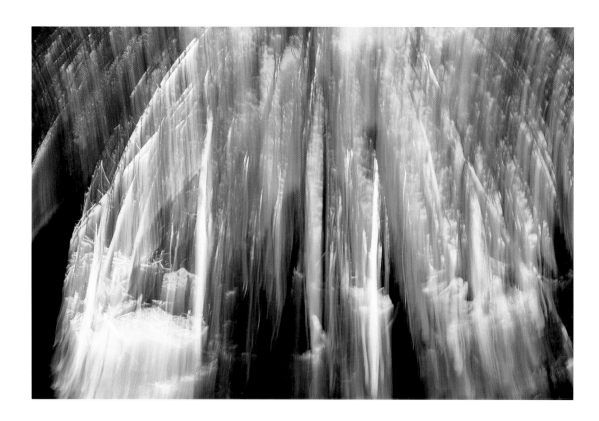

"Glimpse of the Beyond," Anthony Island, Haida Gwaii, BC, 1982

Once they, too, had been forest trees, till the Indian mutilated and turned them into bare poles. Then he enriched the shorn things with carvings. He wanted some way of showing people things that were in his mind, things about the creatures and about himself and their relation to each other. He cut forms to fit the thoughts that the birds and animals and fish suggested to him, and to these he added something of himself. When they were all linked together they made very strong talk for the people. He grafted this new language on to the great cedar trunks and called them totem poles and stuck them up in the villages with great ceremony. Then the cedar and the creatures and the man all talked together through the totem poles to the people. The carver did even more – he let his imaginings rise above the objects that he saw and pictured supernatural beings too.

KLEE WYCK

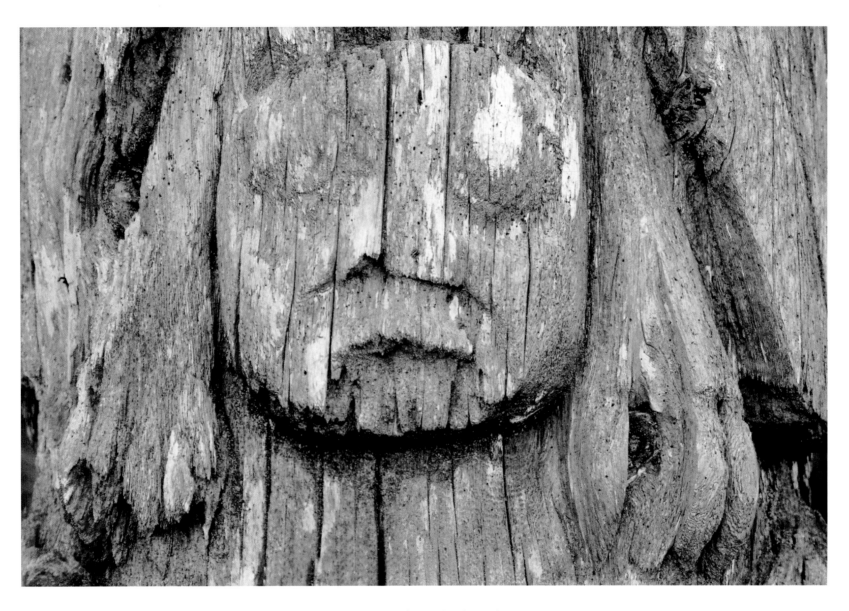

"Guardian," Ninstints, Anthony Island, Haida Gwaii, BC, 1982

"Nurse Log," moss spores, Anthony Island, Haida Gwaii, BC, 1982

Above the beach it was all luxuriant growth; the earth was so full of vitality that every seed which blew across her surface germinated and burst. The growing things jumbled themselves together into a dense thicket; so tensely earnest were things about growing in Skedans that everything linked with everything else, hurrying to grow to the limit of its own capacity; weeds and weaklings alike throve in the rich moistness.

Memories came out of this place to meet the Indians; you saw remembering in their brightening eyes and heard it in the quick hushed words they said to each other in Haida.

KLEE WYCK

"Emily Carr Country," Moresby Island, Haida Gwaii, BC, 1982

"Sea Lions," west coast of Moresby Island, Haida Gwaii, BC, 1982

Grey and gentle, the dusk ran down the Skidigate Inlet, that long narrow waterway between the islands of the Queen Charlotte group. Nobody used this waterway now. The few Indian villages on the Inlet and on the wicked West Coast of the islands were dead, forsaken. It is a passionate coast — wild, cruel. The chug, chug of our gas engine was the only sound in all the world. Jimmy the Indian snapped the gas off and our boat snuggled her nose between the rocks of a little island.

"Gull Island. Eat now," said the Indian.

Gull Island was small, rocky, and round. It had no trees: was only a rounded heap of loose rocks, sedges, and scrub bushes. Sea-gulls came there to nest. The sheep dog and I were the first to jump ashore. The dog ran forward, nosing; a gull rose from the sedges with an angry squawk.

THE HEART OF A PEACOCK

"A Nervous Moment," sea otter, Vancouver, BC, 1987

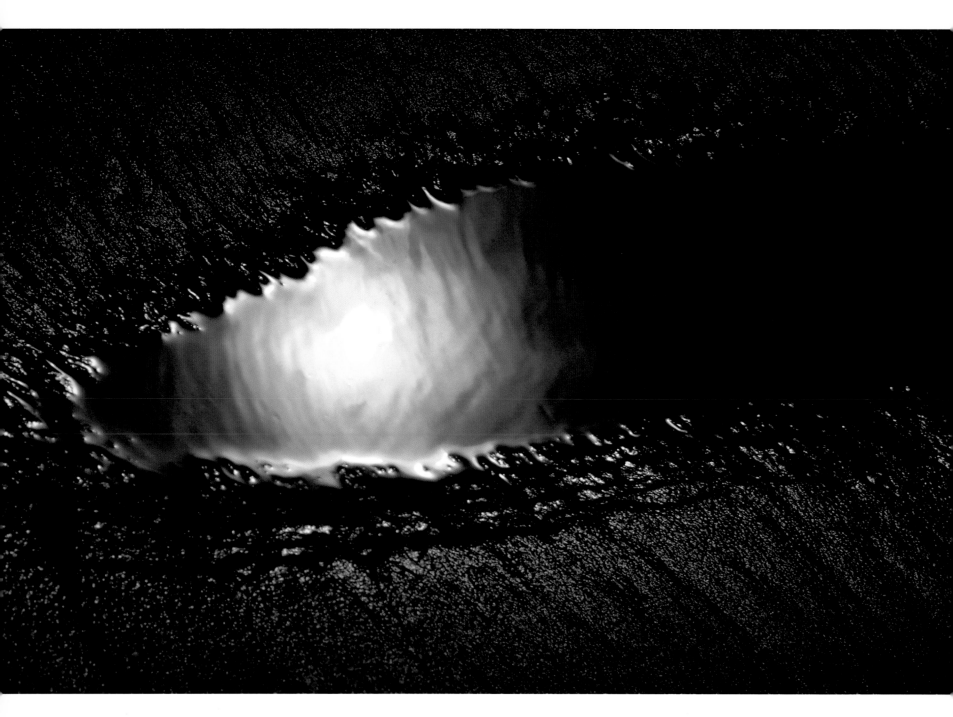

"Eye of the Beholder," reflection of sun in wet sand, 1988

Eye of the Beholder

ROVING THE PACIFIC RIM

"It's fine here. Nobody pesters you. The great wide beach is yours for the taking, its lapping
waves and its piles of drift all yours. The roses on the bank, bursting in a riot of cool pink from
the piles of deep green leaves, toss out the most heavenly perfume. I love to pass the corner where the
spring gurgles up out of the black earth. The roses are so busy there drowning the old skunk
cabbages' smells and the birds are applauding us with wing-flapping and such shoutings."

HUNDREDS AND THOUSANDS

My 1982 excursion to Haida Gwaii turned out to be the beginnings for me of a lot of travel, photography, teaching, and workshops — in fact twenty years of it. In the autumn of 1983, I was conducting photography workshops in Prince George and in the San Juan Islands south of Victoria. Since my itinerary took me to Vancouver Island, I added on an extra three days to visit Pacific Rim National Park. The afternoon I arrived on the beach felt like a replay of my time at Ninstints. The smoke from fires farther north had drifted down the coast and had transformed the entire panorama into a mirage of opalescent hues (see pages 48 and 49). Little did I realize, as I fell in love with the expansive beaches and surrealistic colours, that I would be returning here many times in the years to follow. So compelling was the resultant photo session that I completely forgot I needed to be in Victoria for my early ferry crossing to Port Angeles the next morning. The following winter, I began the first of several seasons conducting classes in the Bahamas, followed by photography expeditions

to Ecuador and the Galápagos Islands. It was at my first round of teaching on Eleuthera Island that I met Sharron Milstein, who suggested we run a photography workshop at Tofino on the west coast of Vancouver Island and take participants to photograph the many exotic locations in Pacific Rim National Park. Ocean Village Beach Resort proved to be the ideal location to house the group and conduct critiquing and teaching sessions complete with slide processing. Through Fred Chapman, who in his own right is a West Coast photography legend, I met Paul Lazarski, a young (at the time) virtuoso with the camera, who also just happened to be an unrepentant admirer of Emily Carr and a store-house of knowledge of the natural history of the area.

And so it came to be, a threesome that survived through eight jam-packed days for five seasons. Sharron promoted and organized, served as mother-confessor, as well as doing some of the teaching. Paul led the field trips, took the role of nature interpreter, helped with slide critiquing, and taught some of the newer students the fundamentals of the camera. I did the majority of the instruction and tried to curb my excitement enough to get a few hours' sleep each night. Because the sessions were always in late May, the days were long, and with twenty participants plus some partners, there was always more than enough enthusiasm. The workshop was called "Pacific Rim Dimension."

As we were organizing for our first onslaught of photographers, Sharron said she had a book called *Hundreds and Thousands* and offered to type out key quotations from Emily Carr that we could tack on the wall or on the door of the meeting room. Paul gasped in astonishment: "I've got the same book. I was going to do that!" I quietly got out my own copy, and we all three had a great laugh. Now it was the Group of Four, as Emily quickly became an inseparable part of the team. We did more than post Emily pin-ups on the door. We took turns choosing selections, read from her journal in our teaching sessions, took her quips and quotes into the field, and at times even assigned students the task of making images that they felt expressed a chosen passage.

When I projected my slides of Long Beach taken on that unforgettable opalescent afternoon, Paul shielded his eyes in dismay. "Disgusting!" he cried. "I've done fifty solo kayak trips along that stretch of coastline, and have never seen an atmosphere that gorgeous. You pop out from Saskatchewan and get it on your first visit!" I laughed, slightly embarrassed by my good fortune. It seemed to me that the ethereal filter through which I had peered that day was the way Emily saw the coast all her life.

Carr's journal entries assisted us as we strove not just to train our photographic eyes, but, as Emily would say, our "higher eyes." We found the journal excerpts to be a marvellous complement to teaching visual design as well as camera technique. She would prod us, "Distort if it is necessary to carry your point but not for the sake of being outlandish." Another quote that got a lot of coverage was "Do not do extraordinary things but do ordinary things with intensity. Push your idea to the limit, distorting if necessary to drive the point home and intensify it, but stick to one central idea, getting it across at all costs." We would even take the liberty of changing the nouns to fit the medium of photography: "paint" became "emulsion," "canvas" was "film," and "a painting" got translated as "a photograph." "If there is no movement in a painting, then it is dead paint" spoke pretty plainly to us, no matter what language it was spoken in, and often prompted us to work harder at our compositions or literally try some unorthodox swirls of the camera during a long shutter release to produce a feeling of motion. Photography, because it is so simple at one level to take "snapshots," is often seen by students as a second-class artform. Having Emily as a coach and assessing our images by borrowing from her vocabulary helped all of us to pay more attention to our seeing and take more pride in our work.

Her daily pep talks, adapted if needs be for our purposes, were the most popular candidates to be tacked on the door: "Make your own soul your judge. If your photograph says something to someone else's soul that's grand but our own soul has got to learn the language before it can talk."

A common theme for our late-night teachers' huddles as we prepared for each new day was how much direction to provide versus how much each individual should be free for independent exploring and self-discovery. It helped to remember how Emily maintained her own integrity while studying the art and philosophy of Lawren Harris, one of the Group of Seven: "Lawren's work influenced me. Not that I ever aspired to paint like him but I felt that he was after something I wanted too." That was it in a nutshell. We didn't want to copy. We weren't seeking her colours or tones, her subject matter, the exact locations where she planted her easel. But she, like Lawren Harris, was after something we wanted, too, and that something was her way of seeing, her desire to experience oneness with the natural world, and a passion to express that connection. Finding our own viewpoints and material was certainly not a problem, because the park stretched

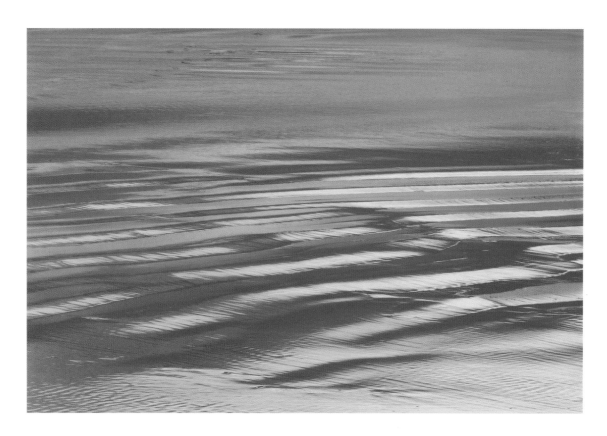

"Sublime," MacKenzie Beach, Tofino, BC, 1987

from Tofino to Ucluelet and beyond and was so grand that there was much to attract the eye. Emily Carr Country was the sweeping expanses of sand and surf and her beloved woods complete with their sanctuaries for camera and soul. I think, too, that as limitless as Emily Carr Country felt to us as a place to explore and to liberate our way of seeing, and doing, and being, it was good to know that right down the coast from us, at Ucluelet, Emily Carr had made her first drawings of Native village life. The year was 1899. Almost a century later, we were strolling over the same beaches, tripods slung over our shoulders, sucking the salty breezes into our lungs and enjoying nature's wonderland still unblemished and unlogged, thanks to the foresight of those who decreed that "this will be a National Park for all people for all time."

In the early eighties, many of us in those workshops weren't completely comfortable about referring to God in our photographs, perhaps because it felt too much like the religious training of our youth against which we were still rebelling, but Emily, who never totally abandoned and later reclaimed a Christian perspective of nature, used

liberal doses of "God" and "Lord." When her journals were published, many of her religious exclamations were edited out simply to tone down the redundancy, but there were certainly plenty left in. It was virtually impossible to ignore. So we, too, with Emily as our moral den mother, found ourselves referring to God, regardless of our own religious persuasions. "To attain in art is to rise above the external and temporary to the real of the eternal reality, to express the 'I am,' or God, in all life, in all growth, for there is nothing but God." Sometimes her pronouncements referred to a feminine force: "Half of painting is listening for the 'eloquent dumb great Mother'(nature) to speak. The other half is having clear enough consciousness to see God in all."

On one occasion, however, a young woman exclaimed that she had had enough of "the Lord" in Emily's writings and would like to change the quotes to "the Goddess." The group then got into creating their own versions and even came up with their own poetry, especially for sharing at our final evening performance. "Oh all ye works of the Lord, bless ye the Lord – joyous worshipping into the woods and mountains, the work of the Lord" took on some novel and liberated adaptations. The one thing we could agree on was that Emily, hovering overhead, must have loved being the cause of such revelry, if not outright rebellion!

What I remember most of those wonderful days at Pacific Rim was the camaraderie and learning to respect each other regardless of our individual beliefs. We learned by doing and by sharing, and we never did know, when the tears and smiles had subsided, if we had learned more from all the successes and failures that got projected onto the screen, or the sheer inspiration that comes from watching each other grow and blossom. Whatever the true dynamics, Emily would have been proud and her spirit sublimely happy here.

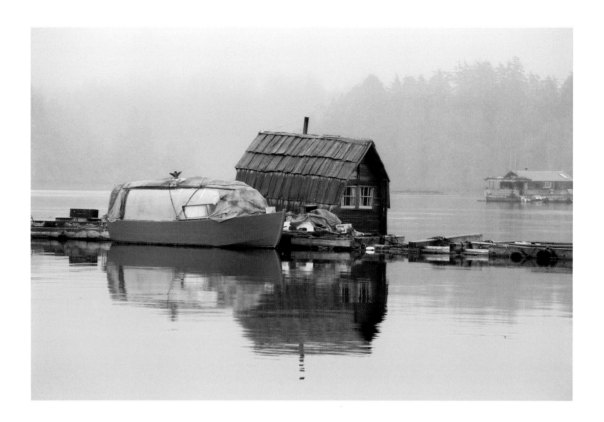

It seems as if those shimmering seas can scarcely bear a hand's touch. That which moves across the water is scarcely a happening. . . . It's more like a breath, involuntary and alive, coming, going, always there but impossible to hang onto. . . . Only spirit can touch this.

HUNDREDS AND THOUSANDS

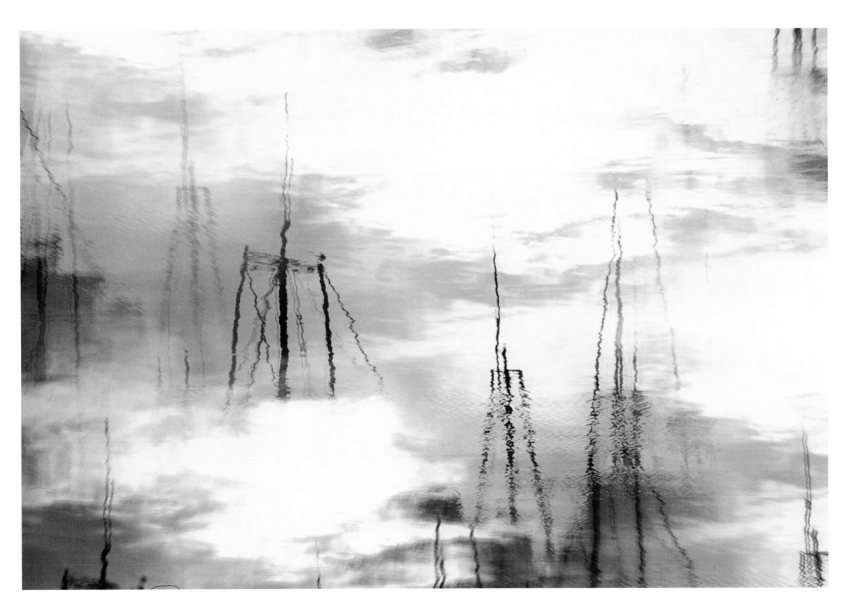

"Spirit's Touch," (inverted reflection) Fisherman's Wharf, Victoria, BC, 1980

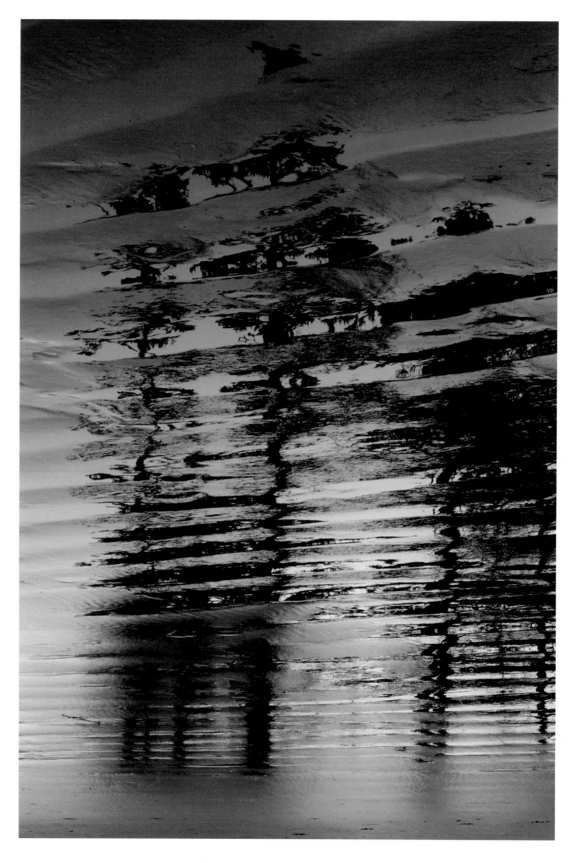

"Venetian Blind," reflection of trees on wet sand (inverted), 1986

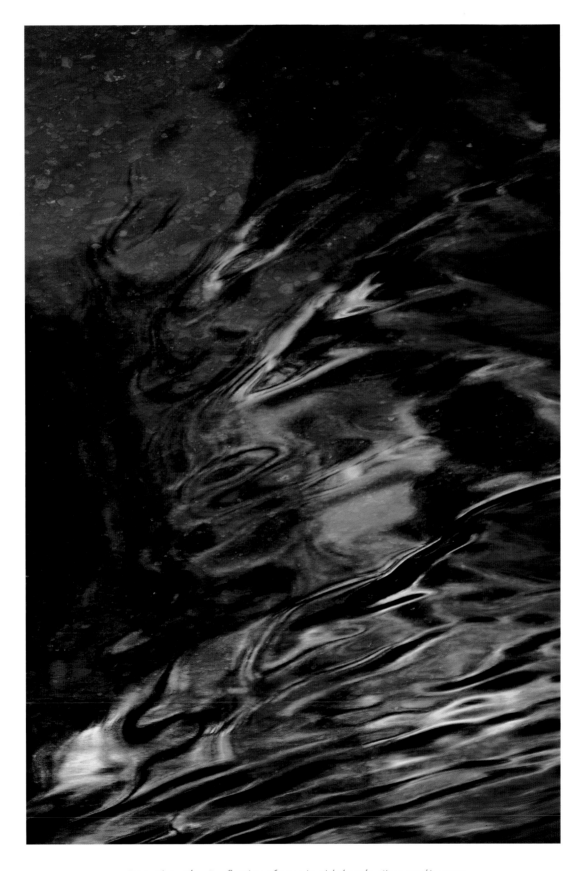

"Venetian Glass," reflection of trees in tidal wake (inverted), 1986

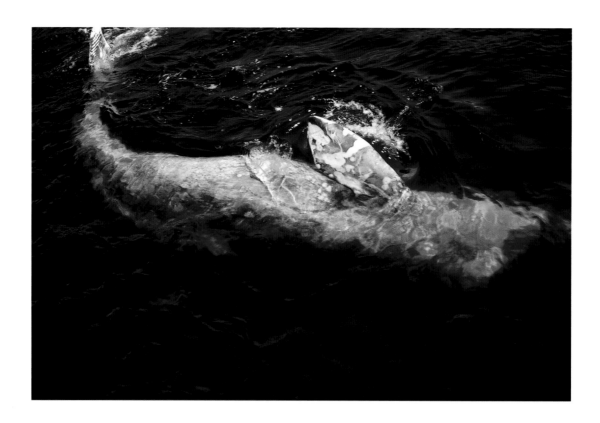

"Just a Fluke," grey whale, Grice Bay, near Tofino, BC, 1984

Movement is the essence of being. When a thing stands still and says, "Finished," then it dies. There isn't such a thing as completion in the world, for that would mean Stop! Painting is a striving to express life. If there is no movement in the painting, then it is dead paint.

HUNDREDS AND THOUSANDS

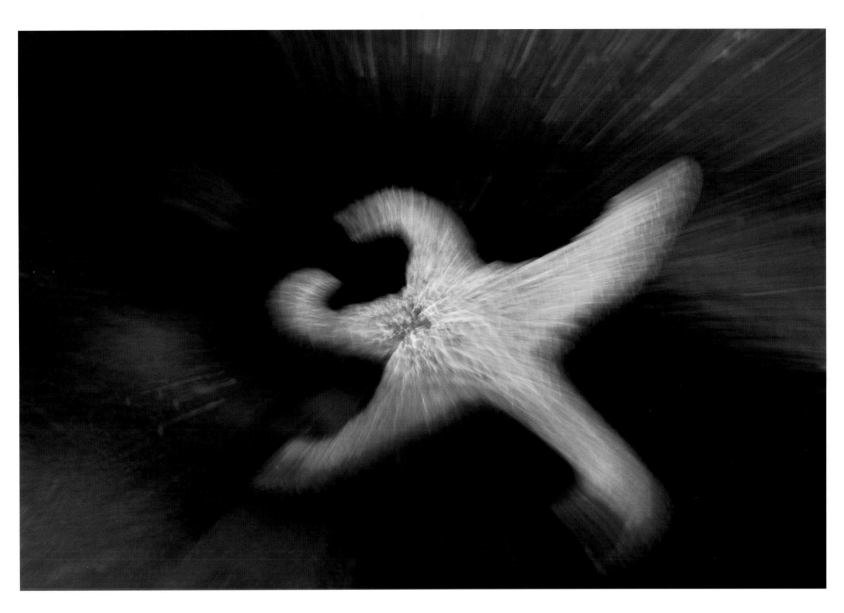

"Ballet Star," zooming motion on sea star, 1997

"Ocean Treasure," zooming motion on sea star, 1988

"Galactic Voyage," multiple exposure on sea star, 1985

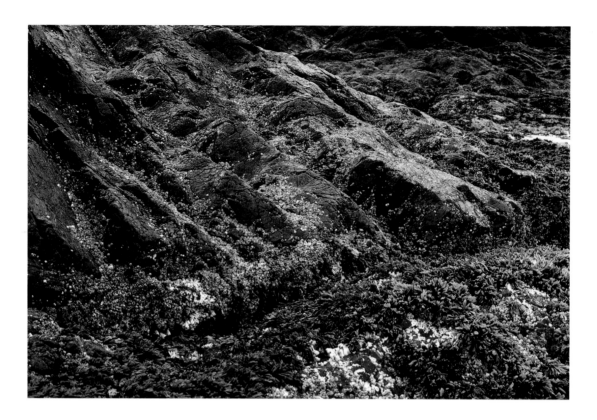

"Kelp and Barnacles," low tide, Lyle Island, BC, 1984

There is no right and wrong way to paint except honestly or dishonestly. Honestly is trying for the bigger thing. Dishonestly is bluffing and getting through a smattering of surface representation with no meaning, made into a design to please the eye. Well, that is all right for those who just want eye work. . . . The love and attraction goes no deeper than the skin. You've got to love things right through.

HUNDREDS AND THOUSANDS

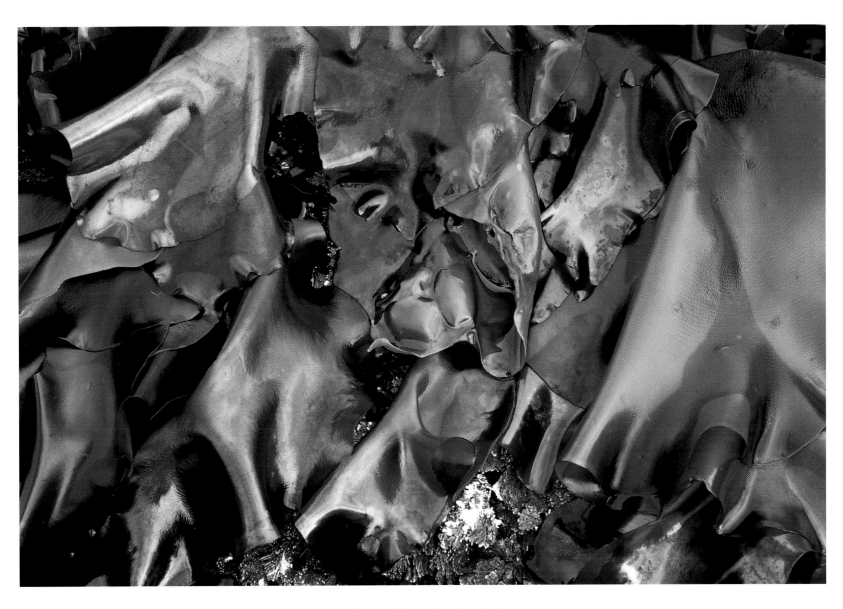

"Masquerade," rainbow kelp, Lyle Island, BC, 1985

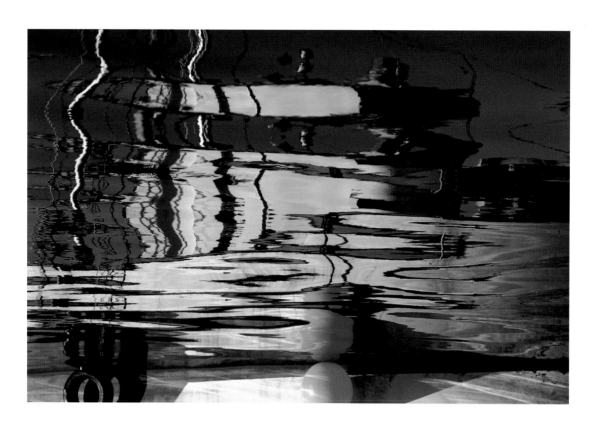

"Water Colours," fishing boat reflection (inverted), Tofino, BC, 1986

Great care should be taken in the articulation of one movement into another so that the eye swings through the whole canvas with a continuous movement and does not find jerky stops, though it may be bucked occasionally with quick little turns to accelerate the motion of certain places. One must ascertain first whether your subject is a slow lolling one, or smooth flowing and serene, or quick and jerky, or heavy and ponderous.

HUNDREDS AND THOUSANDS

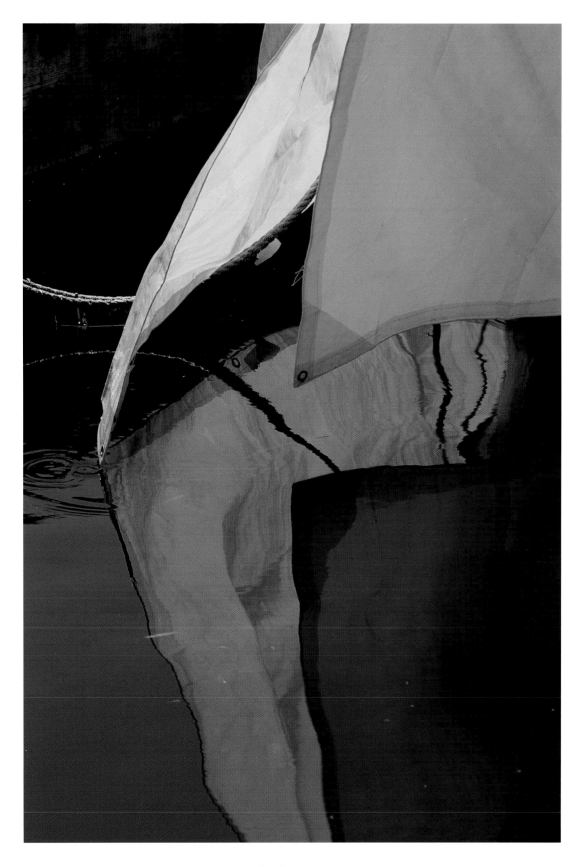

"Tarpaulin," harbour at Tofino, BC, 1986

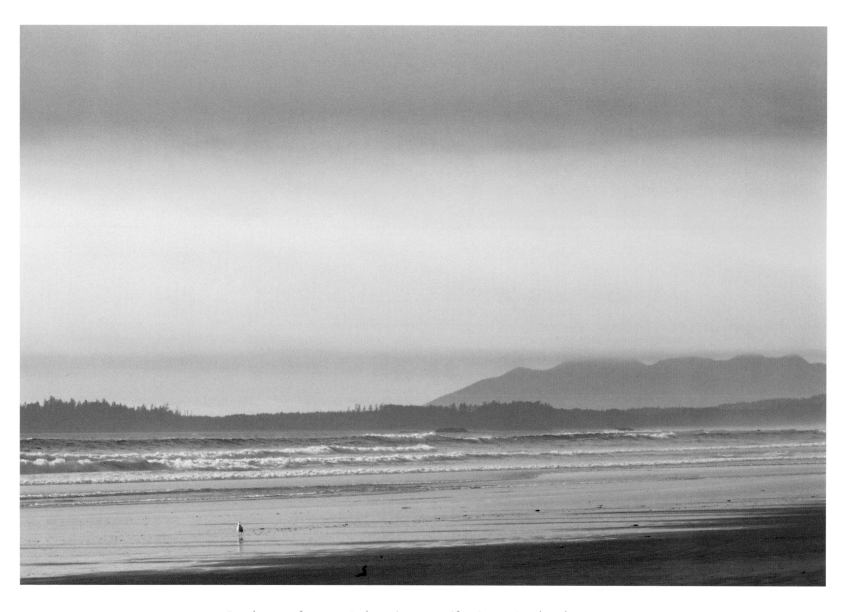

"Opalescent Afternoon 1," Florencia Bay, Pacific Rim National Park, BC, 1983

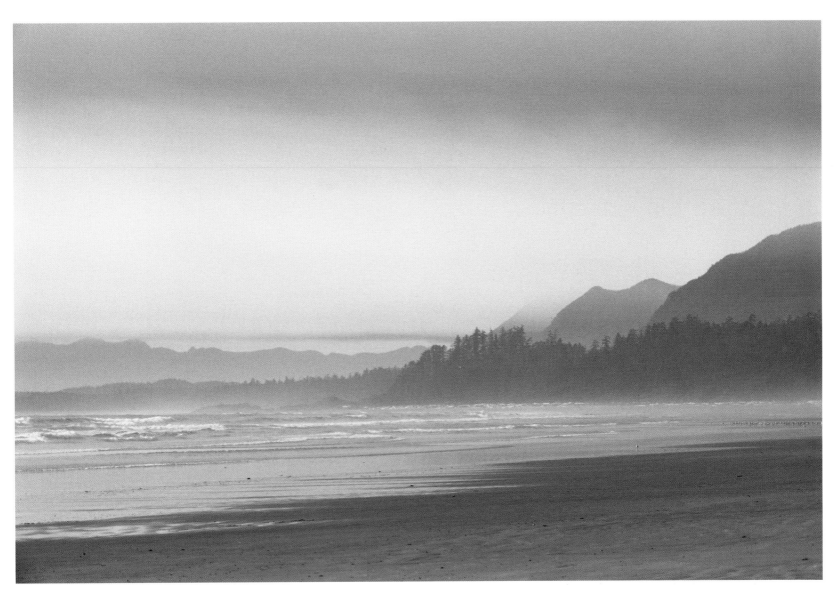

"Opalescent Afternoon 2," Florencia Bay, Pacific Rim National Park, BC, 1983

"Rainy Day Blues," Pacific Rim National Park, BC, 1986

The rain pours. I have put us in and pulled us out until I feel like a worn concertina. If it does it again, I shall ignore it and drown. This is our lazy old April's postscript in May. Fool, fool, fool, that is what I called myself to leave a comfortable home to be drowned and frozen, to cope with wet wood and primitive stove and the bucksaw and water lugged from the spring, this pattering through puddles in a cotton nightgown and rainboots and pleading with the wet wood while hunger and hot-drink longings gnaw your vitals. But, at last, the fire began to burn the sticks, the kettle began to boil, the sun began to shine and I began a new chapter.

HUNDREDS AND THOUSANDS

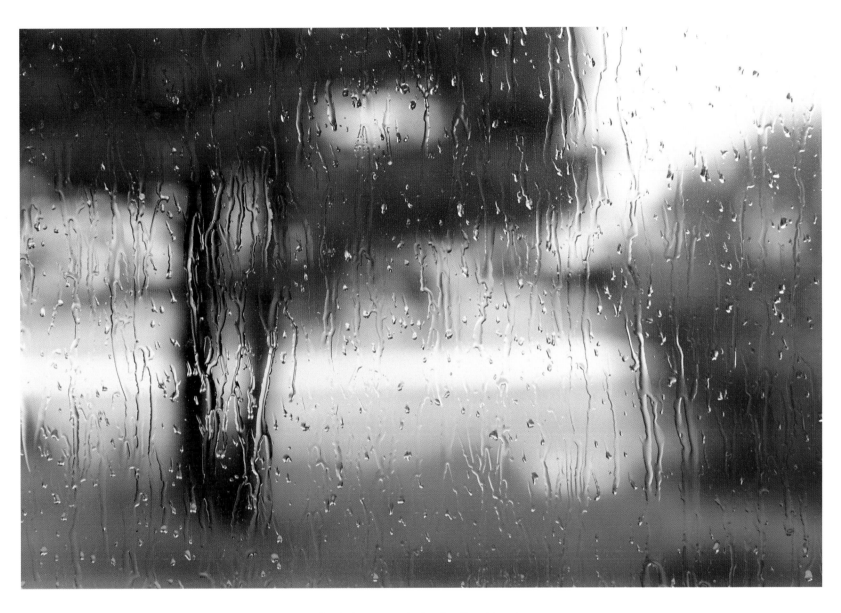

"Raindrops on Window," Tofino, BC, 1987

"Red Alert," detail of sea star, 1984

In the swampy places and ditches of Greenville skunk cabbages grew — gold and brimming with rank smell — hypocrites of loveliness peeping from the lush green of their great leaves. The smell of them was sickening.

KLEE WYCK

"Skunk Cabbage," Grice Bay, near Tofino, BC, 1984

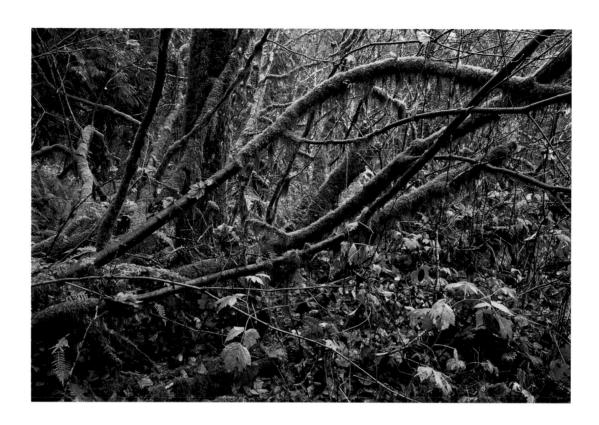

"Moss-drenched," Lynn Canyon, North Vancouver, BC, 1987

A vague artist woman came tonight. She is well-equipped technically and keeps her soul well clamped under and caters to the surface wants of the public, starving her soul that the bodies of herself and family may thrive. She thinks we are here as sort of stop-gaps to keep the universe going and sometimes she doubts if there is any afterwards, she says. She asked what set me working this way. I don't know, any more than a dandelion knows why it's yellow. It's just growth, I guess. Lawren's work influenced me. Not that I ever aspired to paint like him but I felt that he was after something that I wanted too.

HUNDREDS AND THOUSANDS

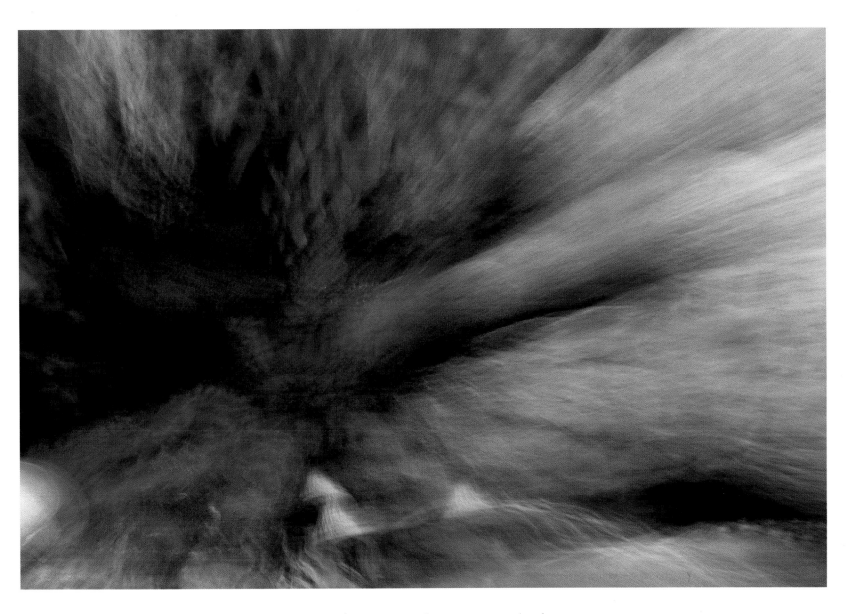

"Texture Study," camera motion on sea star and rocks, 1986

"Dominos," wet sand at low tide, 1986

The sea has no depth. It is all shimmering like a glass-topped table. You could slither things over its surface and they'd go on and on as far as the momentum of your throw. Nothing would sink, just slide over the top. It looks like ice except that it *looks* hot, not cold.

<div align="center">HUNDREDS AND THOUSANDS</div>

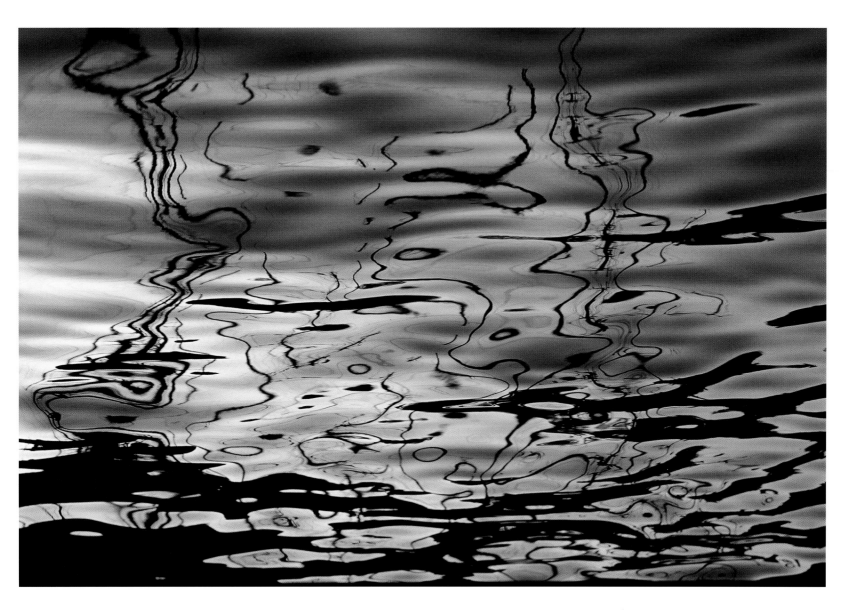

"Caucus," Fisherman's Wharf, Victoria, BC, 1986

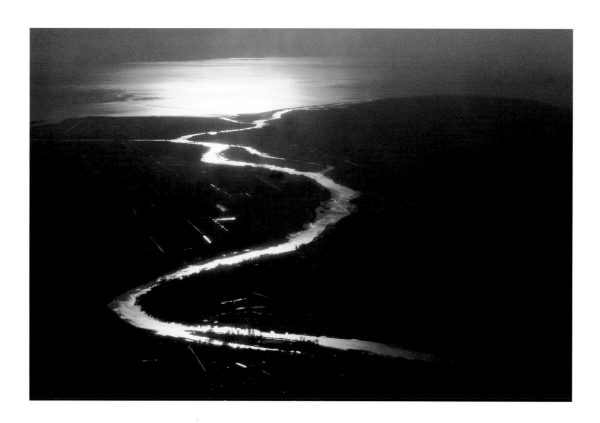

"Fraser to the Sea," aerial view, Vancouver, BC, 1985

Half of painting is listening for the "eloquent dumb great Mother" (nature) to speak. The other half is having clear enough consciousness to see God in all.

Do not try to do extraordinary things but do ordinary things with intensity. Push your idea to the limit, distorting if necessary to drive the point home and intensify it, but stick to the one central idea, getting it across at all costs. Have a central idea in any picture and let all else in the picture lead up to that one thought or idea. Find the leading rhythm and the dominant style or predominating form. Watch negative and positive colour.

HUNDREDS AND THOUSANDS

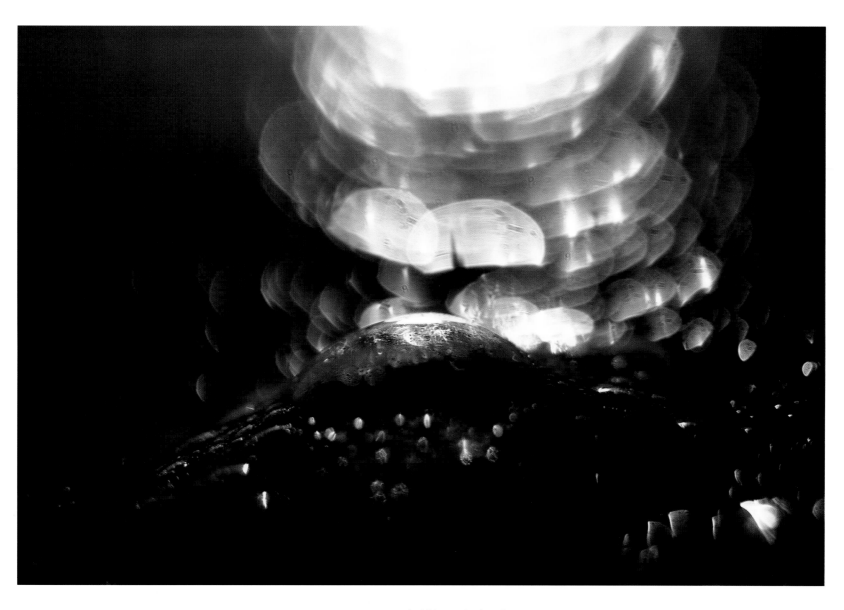

"Foam Mountain," bubbles at high tide, 1984

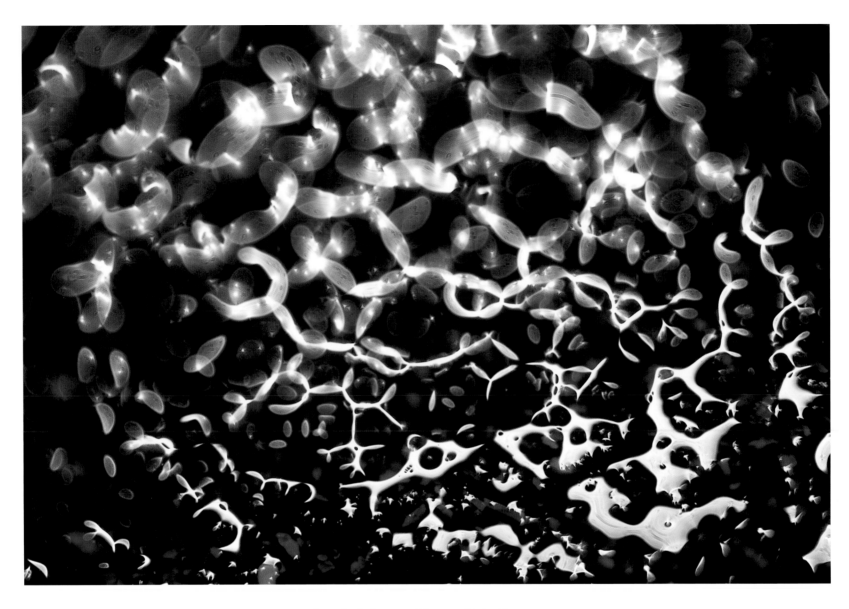

"Revelry," close-up of foam at high tide, 1984

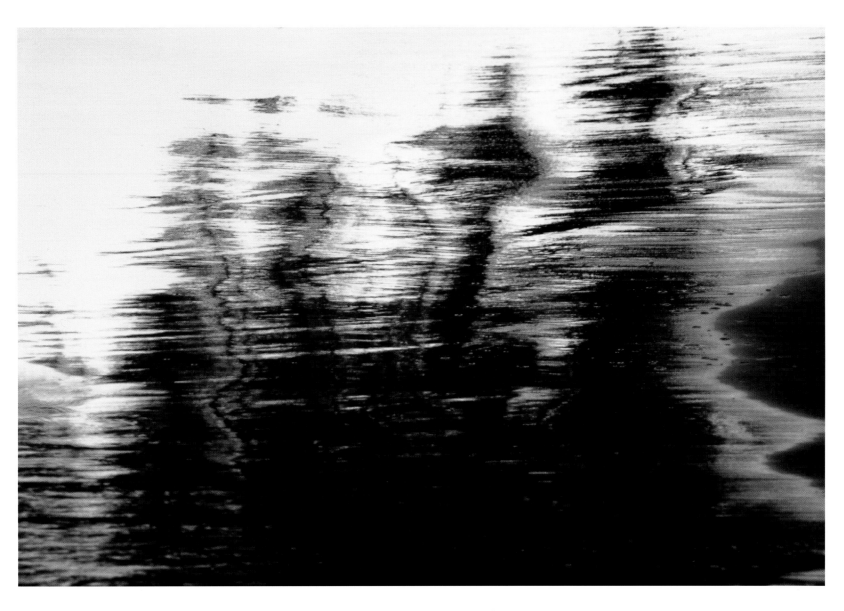

"Trees on the Beach," reflection in wet sand (inverted), 1984

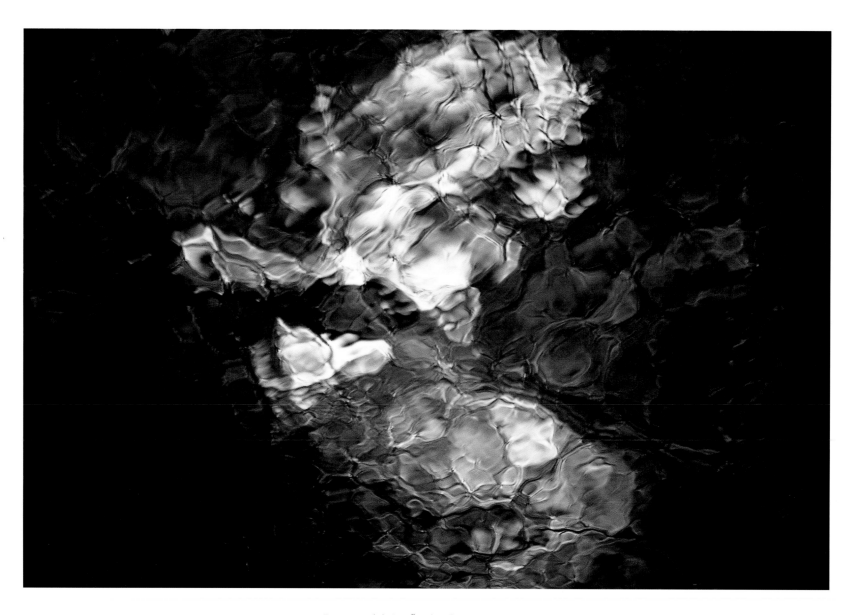

"Forest Spirit," reflection in stream, 1985

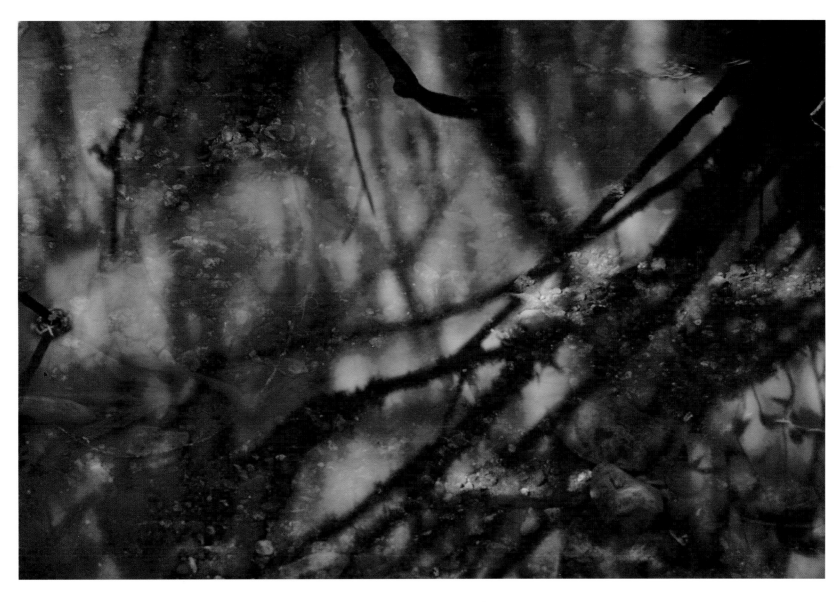

"Golden Pond," reflected forest foliage, 1986

"Felicity," out-of-focus exposure of backlit foliage, 1986

I am circled by trees. They are full of chatter, the wind and the birds helping them. . . . In the afternoon, when the sun has dodged down and blares forth and gets glaring, red hot and bold, I like to get off into the calm woods. When he has gone, leaving just a trail of glory across the sky which the pines stand black against, it gets wonderful again and presently an enormous motherly moon comes out of the East and washes everything and all the sweet cool smells come out of things, not the sunshine smells of day that are like the perfumes and cosmetic smells of fine ladies but the after-bath smells, cleanliness, fine soap and powder of sweet, well-kept babies. And when you put the van lamp out and lie in the cool airy quiet, you want to think of lovely things.

HUNDREDS AND THOUSANDS

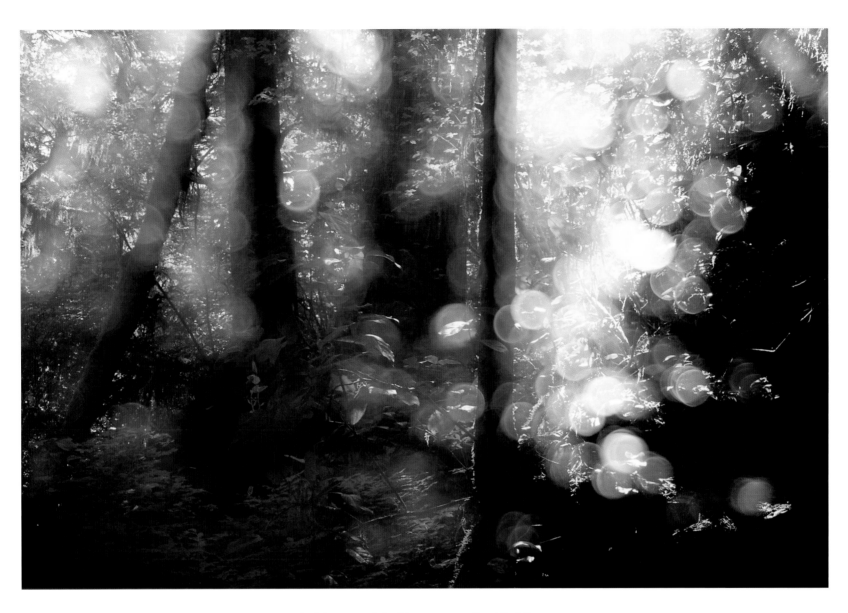

"Soul of the Forest," double exposure of backlit foliage, 1986

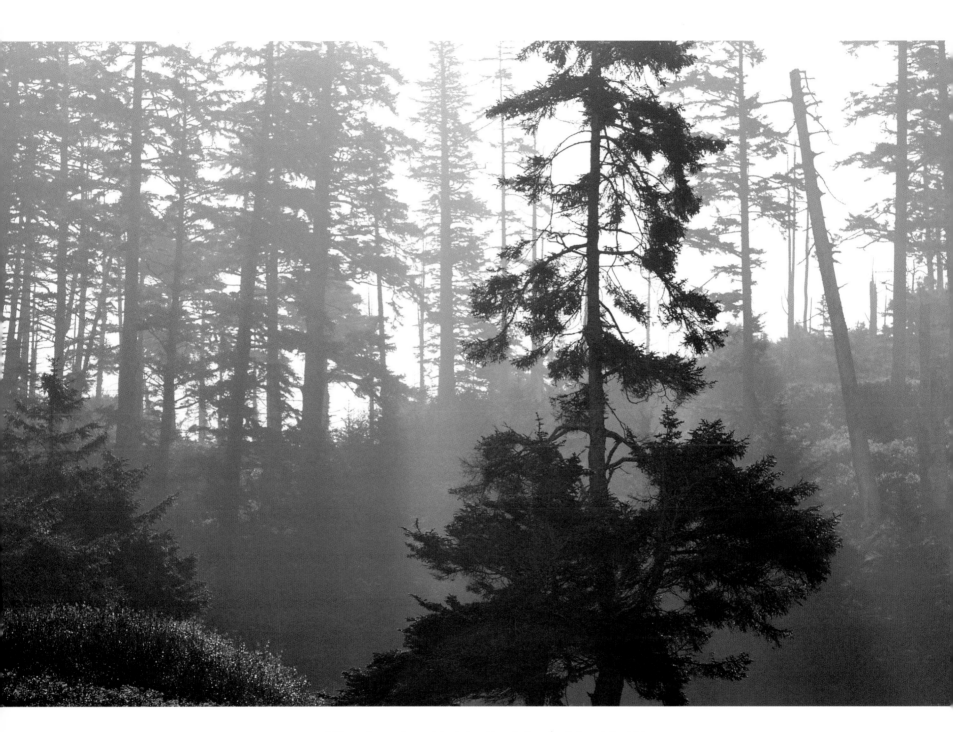

"Silence," morning mist at MacKenzie Beach, Tofino, BC, 1986

In Tune with the Silence

LANDSCAPES OF THE SOUL

"I am looking for something indescribable, so light it can be crushed by a heavy thought,
so tender even our enthusiasm can wilt it, as mysterious as tears."

HUNDREDS AND THOUSANDS

After five years of teaching each spring at Tofino, in 1988 my life took a dramatic turn. In quest of sacred places around the globe, I again left my familiar world, which by now encompassed the West Coast, and set out on a ten-month round-the-world odyssey with my partner, Sherrill, who I had met through Sharron Milstein. I immersed myself completely in photography, spending long hours alone in remote settings. Although virtually all of the terrain was new to me, I began to develop a ritual in my approach to photographing landscape. At popular sites, like the Pyramids at Giza or Uluru (Ayers Rock) in Australia, I would arrive early in the morning before the onslaught of tourist buses and explore in silence. Sometimes, I would start photographing quickly, but often I would wait, not for the light or the right conditions to unfold, but for something less tangible — an awareness, perhaps, a tuning into the unseen dimensions of a specific place. Though I would not have described it this way at the time, I believe I was also waiting for "permission," for a sense that it was all right to be

there, all right to begin photographing. In the process, I got to know these places in much more depth than in my previous work, and more often than not the "knowing" would open up whole new avenues to explore. I was in essence learning to incorporate meditation into my photography, or perhaps more correctly I was introducing my photography into these meditation sessions. By immersing myself in the soul of the landscape, I was then expressing, through my images, landscapes of the soul — photographs that reflected a deeper part of me, a part that felt a profound appreciation for what I had experienced.

This worldwide trip led to three large book projects, *The Sacred Earth*, *Spirit of the Land*, and *Visions of the Goddess*, the latter co-authored with Sherrill, who had become my fiancée at the Married Rocks in Japan and my wife a year after our return in 1989 to Saskatchewan. The preparation for these books resulted in an enormous amount of further travel to forty-five countries. During these subsequent years I gave many talks, slide shows, and concerts of music with dual-projector dissolve, but with only a few exceptions I dispensed with the teaching. It was not until 1995 that Adele Curtis asked if I would co-teach a workshop with her at Point-No-Point, a short distance up the coast from Sooke, on Vancouver Island. Adele had taken a couple of my workshops at Tofino, and not only had she shown herself to be an exceptionally gifted photographer, but she also contributed to the workshops by composing music, singing, and playing the guitar. When Sherrill and I got married, Adele composed and sang a song at our wedding. Needless to say, I was impressed, and when the time was right we became teaching partners. Nor did it hurt that she was a great fan of Emily Carr, having already incorporated Emily's writings into workshops she had been conducting with Sharron. Finding Emily's writings had affirmed for Adele her own long-standing sensual and spiritual experiences of the forest, as well as the joys and frustrations of trying to express them. Part of my reluctance to teach during those intervening years was that I had wanted to take the classes to a deeper, more meditative place, but found that photography students tended to resist, preferring to focus on improving camera technique. In 1996 I experimented with a new approach to teaching called Inner Landscapes, at Hollyhock, a retreat centre on Cortes Island. We treated our photographs as milestones that could reveal key answers to perplexing issues on life's journey. I also employed slide shows with music and slow, dreamlike multiple-image dissolves for group meditation. Going inside proved to be a bit of a stretch for those used to photographing the outside! One photo

buff reported, "You know that journey you took us on? . . . Well, I don't think I even got out of the station!" I left Hollyhock feeling that maybe I should stick to teaching the more mechanical side of photography. But fate would have it differently. One participant in that workshop was Manfred Forest, and although he had bags and cases jam-packed with the latest camera gear and high-tech gadgetry, he had in addition a heart as big as Emily Carr country and a soul that longed to go deeper into the woods. He was a master at slide processing and could bring his portable equipment to our workshop and develop the slides overnight so that we could critique the work the next day. He also encouraged me to continue combining meditation and photography and thus effortlessly became a part of the new team. With his inspiration, Adele and I planned our new workshop and called it "The Soul of the Landscape, Landscapes of the Soul." For the first time in my teaching, I was putting soul first in the billing, and first on the agenda.

But now that we had recognized the unseen world as being a vital part of our pursuit and our teaching, how were we going to put the new focus into practice? Certainly, in past years we had suggested that old-growth forest could be a spiritual place, but we had not attempted to put "real" meditation on the curriculum. The emphasis had been to make photographs of the natural world that expressed a mystical quality, but always with eyes wide open. Did we dare suggest it was all right for photographers to shut their eyes? Maybe not a great way to compose, but, as we discovered, an excellent way to get composed.

Looking for help from Emily Carr, we scoured through our archive of quotes not just for moral rearmament but for ways of teaching the unteachable, of seeing the unseen, of hearing the silence that spoke louder than words. What if we could stretch *our* senses, still *our* minds, and add a pinch of love to the recipe? What might we produce with our little "mechanical boxes" to express our affinity for and connection to the world of spirit?

Our teaching and leadership styles evolved over the four years that we offered Soul of the Landscape workshops. Emily, through her often inspiring, always informative journal writings, invited us to involve all of our faculties and make the entire process a joyous, sensuous experience. We found ourselves going back to rediscover not just Carr the philosopher and inspirer, but Carr the sensualist. I remember when, to our delight, we found her, in a fit of spring fever, revealing the desire to "roll naked in this

soft sopping grass, a direct-from-heaven tub." Adele grinned at me: "You're not going to introduce Roll-Naked-in-the-Grass workshops, are you?" It sounded like fun, but we agreed it would either drastically reduce our enrolment or increase it so enormously that we wouldn't be able to cope! "Soul of the Landscape" seemed daring enough for starters.

What happened, however, was that the soulful title did tend to attract participants to the workshop who were already keen to take their awareness into new realms, who at the same time wanted to improve their photographic skills. We also made sure that at least once each workshop Manfred would empty his camera bag for the group and dazzle them with his shiny new toys!

Another influence on me was Ann Mortifee, the singer-songwriter based on the West Coast. Her pure, unrestrained voice had always taken me to deep places, and when I attended one of her workshops in the early 1990s, she told me my book *The Sacred Earth* affected her the same way. In 1998 and 1999 we combined our talents in weeklong retreats that we named Soulscapes. Together, we produced impromptu meditation pieces where I would project dreamlike images of sacred places slowly blending together as she sang, sometimes creating new compositions, complete with lyrics, as the pictures appeared. The experience of working with Ann was profoundly moving for me, as well as for the fifty or so participants in each workshop. Part of the impact was the realization that all of us, even highly gifted souls like Ann, carry our wounds through our lives and that they can be used to create beauty. Ann believes that, for each of us, the place that holds the greatest pain resides right next to the place of greatest joy. I realize now that it was precisely because of my own feelings of inadequacy that I sought out beauty in my travels, in the natural world around me, and with my camera. Emily, like Ann and me and so many others, had also found a way to transcend her oppression. Emily, as well, seemed to recognize that in order to create from a place deep within, she needed to acknowledge and to confront her greatest unhappiness – a feeling of being unloved or unappreciated.

By the fourth spring, Adele and I had become more confident in our approach and actually talked about the viewfinder as the third eye. We gave assignments where people would "meditate with their cameras," and we encouraged them to limit their conversations during these times. A few weeks before the fourth Soul workshop, I undertook a series of rebirthing sessions in Victoria, ironically only a short stroll away from Emily Carr's birthplace. Rebirthing is a process in which the client, with the guidance of a professional

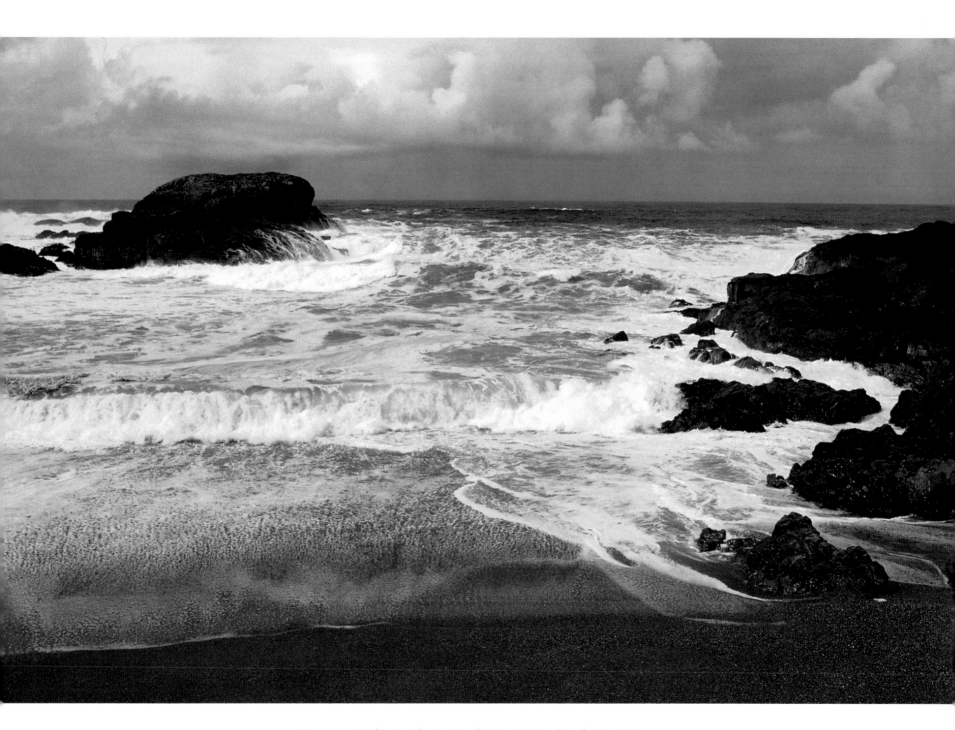

"Seascape," Wikininnish Bay, Pacific Rim National Park, BC, 1987

"rebirther," uses breathing techniques to achieve a deep altered state, and in so doing can more readily access the source of long-standing issues and blockages in his or her life. It is called rebirthing because a person can literally regress to a state of openness and awareness where he or she relives the memories of birth, with all its attendant emotions.

By the time we began to plan our year 2000 workshop, I was starting to enjoy the benefits of my rebirthing experiences, in the form of heightened awareness and creativity, especially in the hours immediately after. I would wander in Beacon Hill Park, with or without my camera, marvelling at the exaggerated colour saturation and the breathless beauty and delicacy of the floral displays, experiencing it all with a reawakened eye. "There must be a way," I said to Adele, " to introduce this depth of connection to the people in our workshop." I had a strong feeling that this was the way Emily experienced the natural world most of the time and the reason why she was so frustrated when she couldn't seem to articulate in her paintings her feelings of intimacy with the forest, her oneness with the universe, the life force, the vibrancy, the aliveness of everything around her.

I suggested to Adele that we simply put the cameras aside for a while and give people an opportunity to form a richer, more vital bond with their surroundings before starting to photograph. "You mean we should tell everybody to go sit on a log on the beach, close their eyes, and meditate?" she asked, a little afraid of what she already knew would be my reply. "Yeah," I said. "Let's just give it a try." She had received some mixed feedback on the meditative aspects of a previous workshop from someone wanting more straight-forward camera instruction and was reluctant to take things too far. "I vote we stick to meditations through the lens," she countered. Then I had a flash, because I felt convinced that it was time to plunge a little deeper. "I'll tell you what. On Monday morning [the workshop was to start Sunday evening], we will all meet at the red gate and proceed down the trail. When we get to the fork, those who want to meditate with their eyes open can follow you to the cove; those who want the full monty can follow me to the beach." She agreed.

At our opening session, we did the usual greetings and set up the schedule for the week. Schedules are quite hilarious, because everything depends on how hard it is raining, so in our class handout we state, "The following schedule is not subject to change unless we decide to change it!" For the last portion of the Sunday-night events, Adele and I each

presented a slide-sound program and requested that during and after the show we all adhere to a code of silence. We also explained the options of the following morning and said that then, too, we were to meet in silence, walk in silence, do the thirty-minute meditation in silence, and continue working and exploring throughout the morning without talking. Gestures and silent communication would be fine, but no speaking allowed. At the fork in the trail the next morning, everyone chose the "closed eyes" meditation, which was great for Adele, because it meant that she could come with us too.

During that silent time together, we formed an unbelievable bond that carried through the entire week. There was a sanctity and dignity established that set the tone for a quiet, meditative approach to all our photography sessions, and, I am convinced, a deeper appreciation for the natural world we were discovering. Reverence and respect also set the stage for an appreciation of the quotes from Emily, which we read each session. You could have heard a pin drop in the room when Adele began to read to the group: "There is a great deal going on here but it is all the still noise of silent growth."

Later, in the workshop, another of Carr's insightful journal entries became an affirmation of what each of us must have already come to realize: "You yourself are nothing, only a channel for the pouring through of that which *is* something, which is all. Your job is to keep that channel clear and clean and pure so that which passes through may be unobstructed, unsullied, undiluted and thus show forth its clear purity and intention. Strive for this thing, for the stillness that should make it possible."

Time seemed not to exist as we made our expeditions to Botanical Beach, Sombrio Beach, and China Beach, to explore the old-growth forest of giant spruce and cedar, to peer into the tidal pools and sea caves, and to join together for lunch breaks, or in the shelter of the high sandstone cliffs when the rain became too heavy. Everyone had their favourite photographs from that time and place. Here are some of mine.

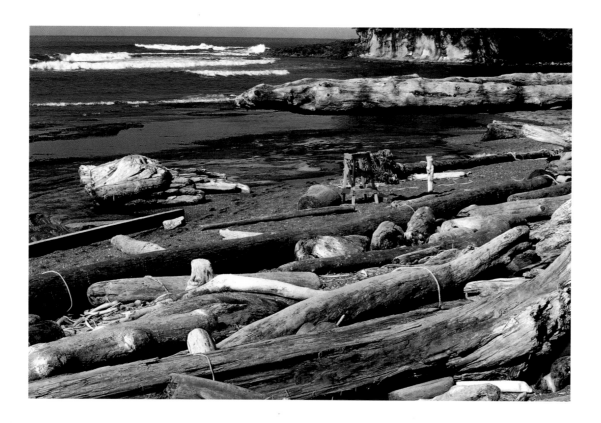

"The Place I Saw," Botanical Beach, BC, 2000

One day I walked upon a strip of land that belonged to nothing.

The sea soaked it often enough to make it unpalatable to the forest.
Roots of trees refused to thrive in its saltiness.

In this place belonging neither to sea nor to land I came upon an old
man dressed in nothing but a brief shirt. He was sawing the limbs from a
fallen tree. The swish of the sea tried to drown the purr of his saw. The purr
of the saw tried to sneak back into the forest, but the forest threw it out again
into the sea. Sea and forest were always at this game of toss with noises.

KLEE WYCK

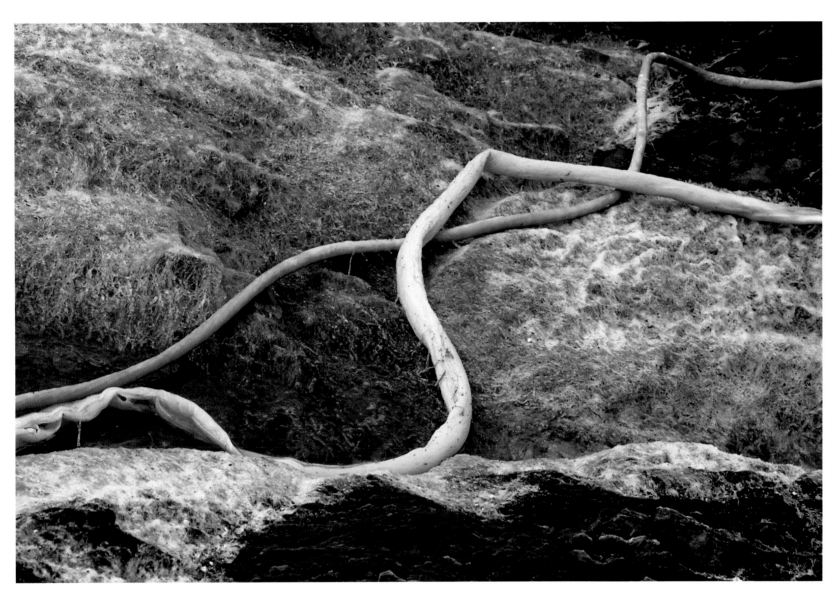

"Bull Kelp," China Beach, BC, 2000

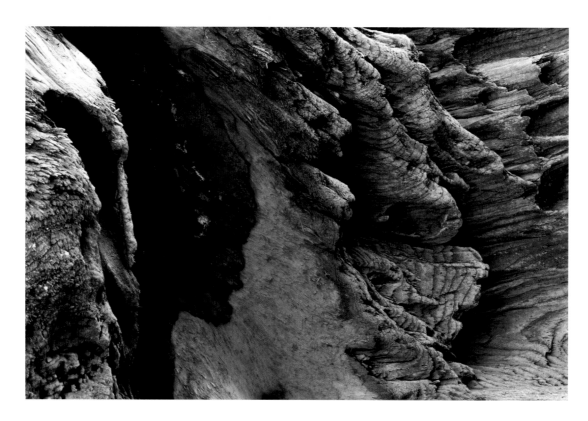

"African Queen," detail of drift log, 2000

In working out canvas from sketches, the sketches should convey the essence of the idea though they lack the detail. The thing that decided you to attempt that particular subject should be shown, more or less. Take that small sketch home and play with it on paper with cheap material so that you may not feel hampered but dabble away gaily. Extravagantly play with your idea, keep it fluid, toss it hither and thither, but always let the *idea* be there at the core. When certainty has been arrived at in your mind, leave the sketch alone. Forget it and put your whole thought to developing the idea.

HUNDREDS AND THOUSANDS

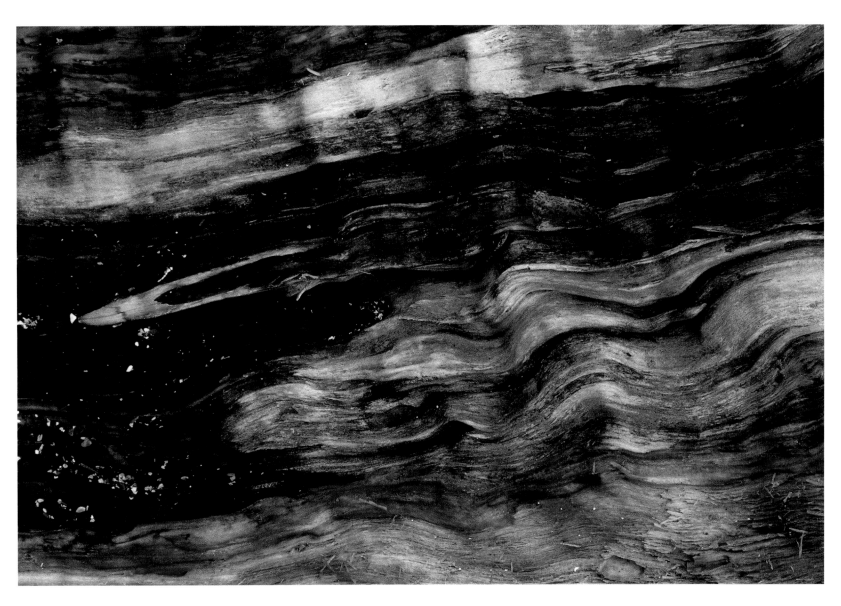

"Conception," close-up of weathered log, 2000

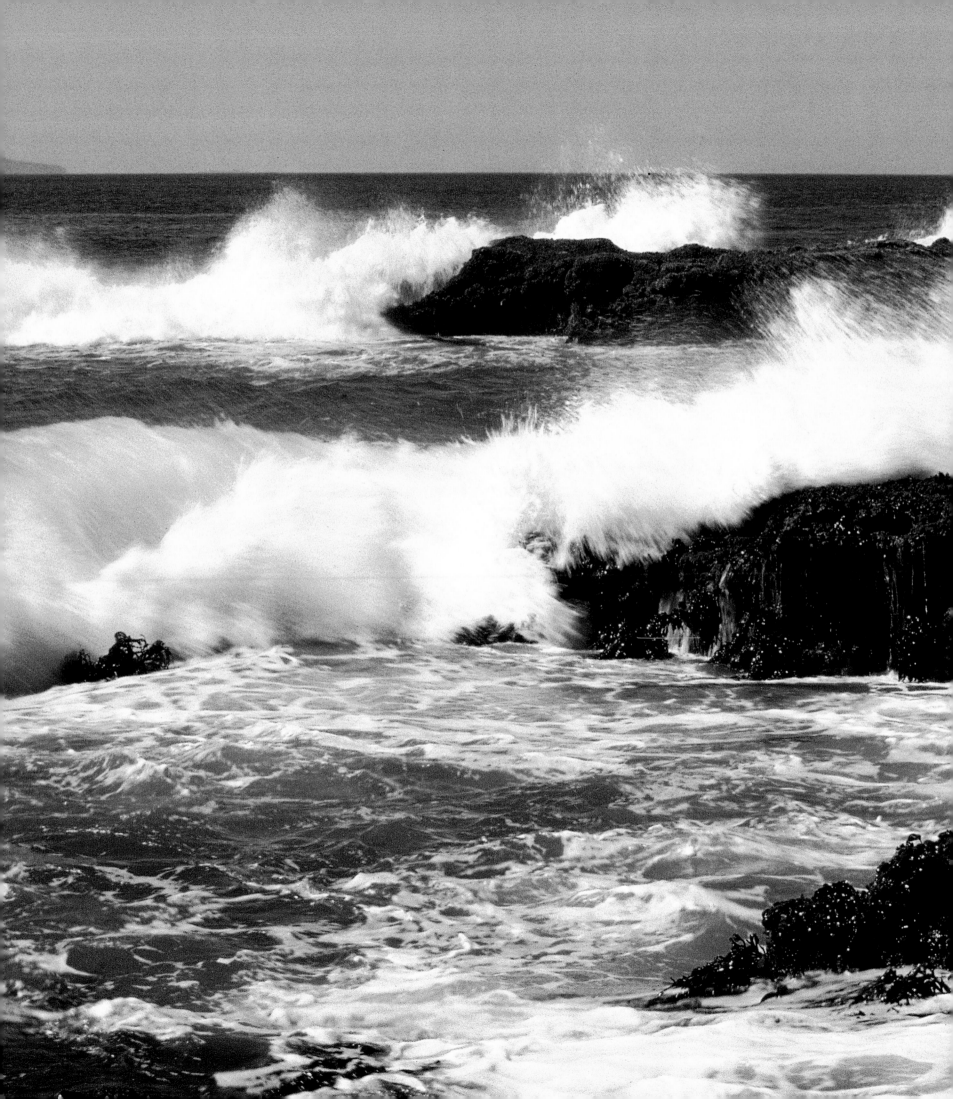

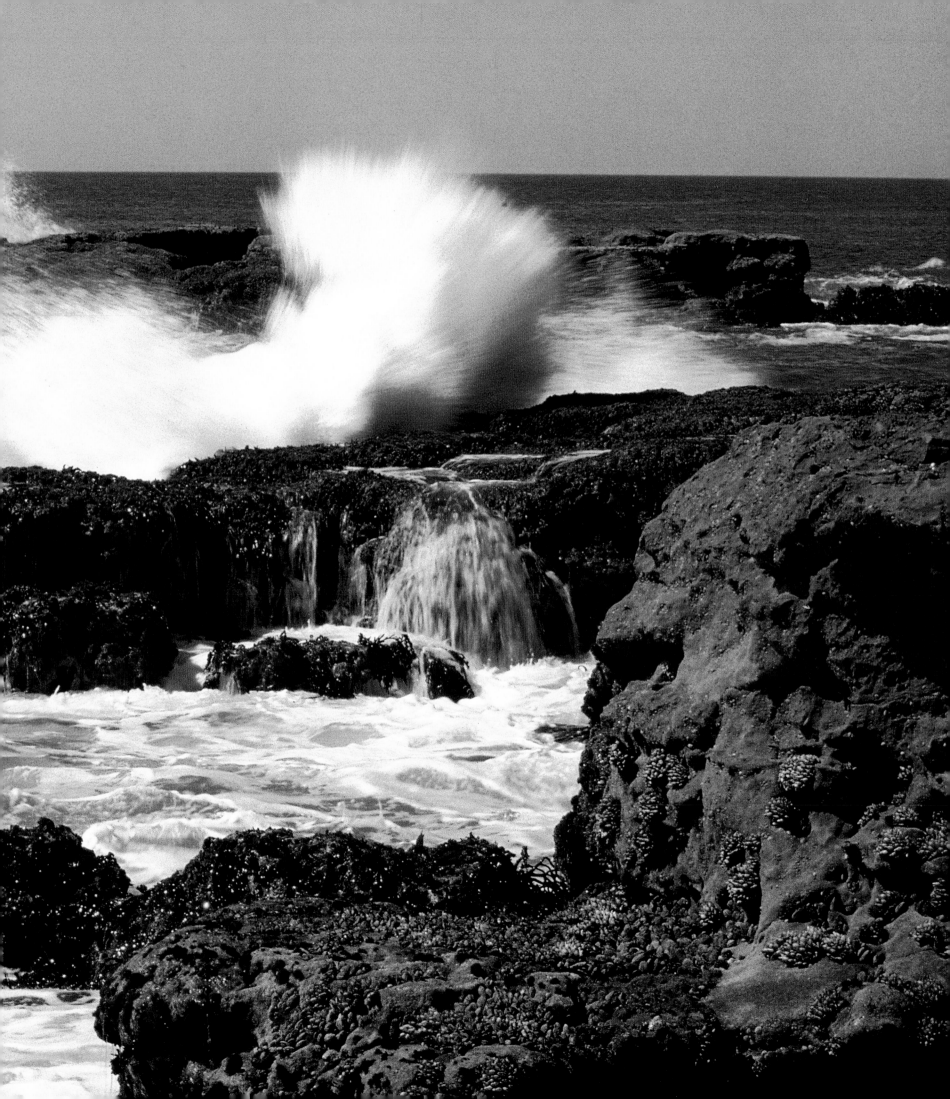

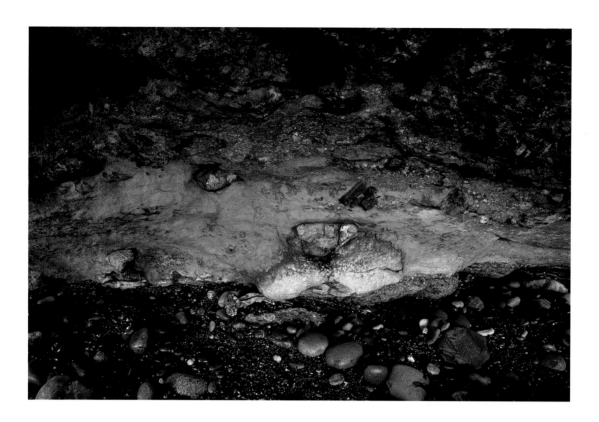

"Sea Cave," low tide, Sombrio Beach, BC, 2000

It is not good for man to be *too* much alone unless he is really very big, with stores of knowledge to draw from and a clear brain to think with. That's the whole problem: a clear brain that can take thoughts and work them out, can filter – clean out – muddy, confused thoughts, can read meanings into things, draw meanings out of things and come to conclusions, a brain that converses with life and can, above all, enable a man to forget himself. The tendency in being alone and not having anyone to exchange thoughts with is to be always on the fence between yourself and yourself.

HUNDREDS AND THOUSANDS

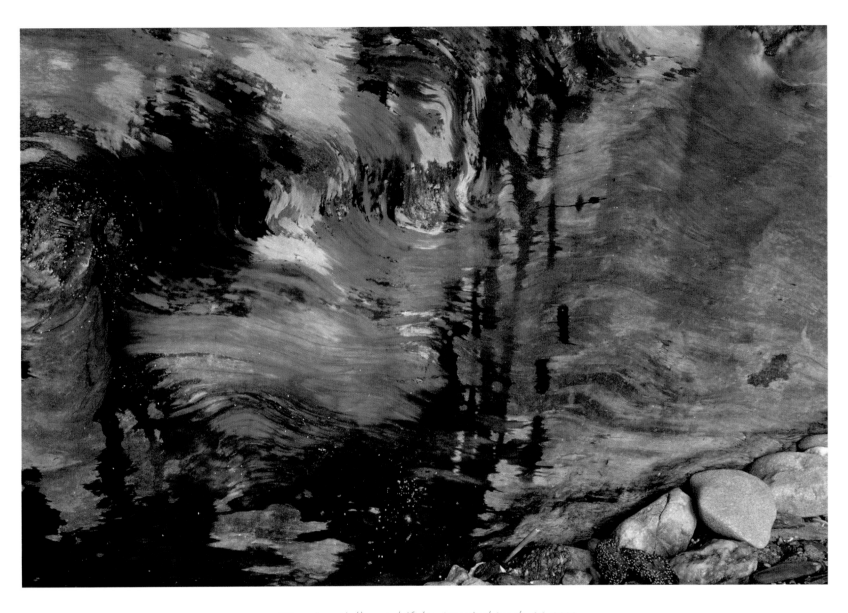

"Tears," partially wet drift log, Botanical Beach, BC, 2000

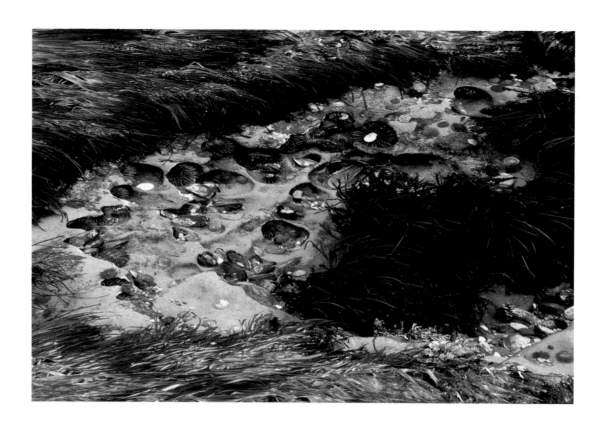

"Harbour," sea urchins and clams in tidal pool, 1997

You yourself are nothing, only a channel for the pouring through of that which *is* something, which is all. Your job is to keep that channel clear and clean and pure so that which passes through may be unobstructed, unsullied, undiluted and thus show forth its clear purity and intention. Strive for this thing, for the stillness that should make it possible.

HUNDREDS AND THOUSANDS

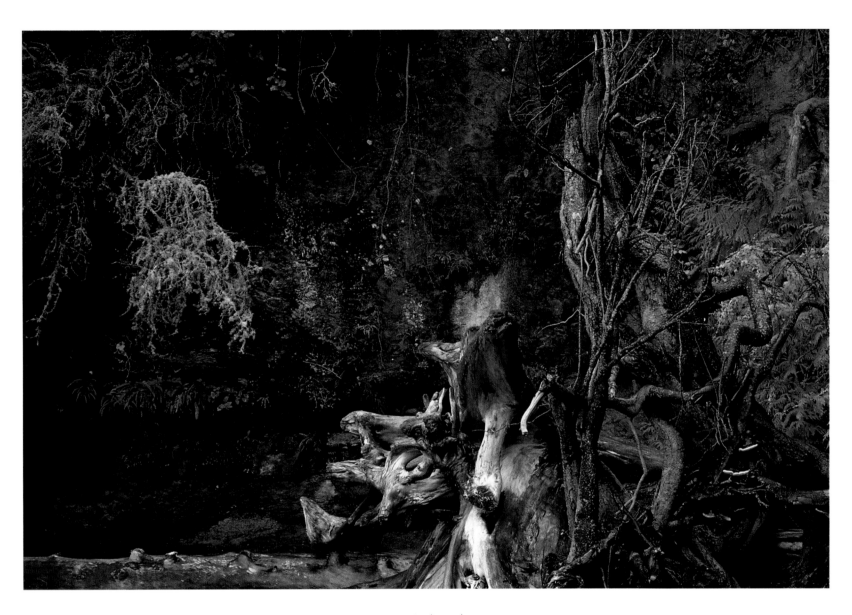

"Roots," Botanical Beach, BC, 2000

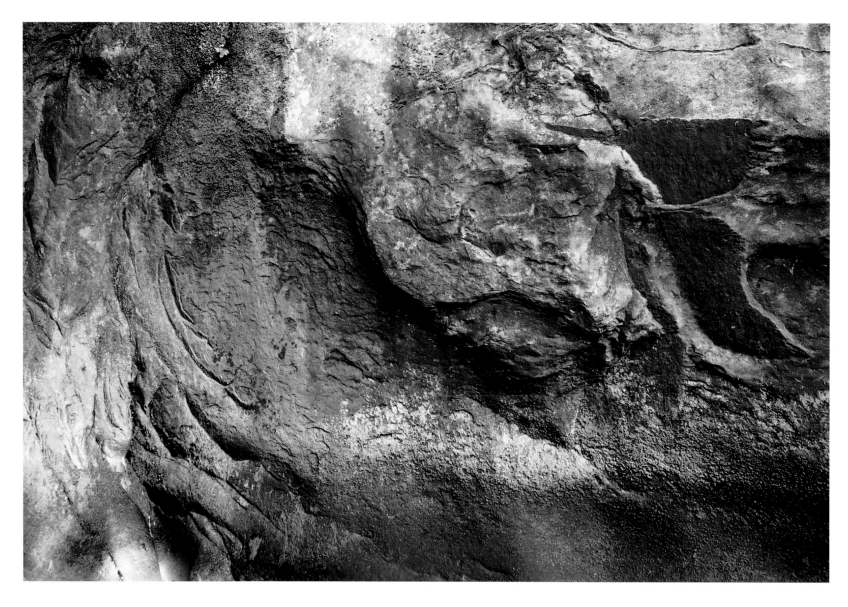

"Hummingbird Cave 1," Botanical Beach, BC, 1996

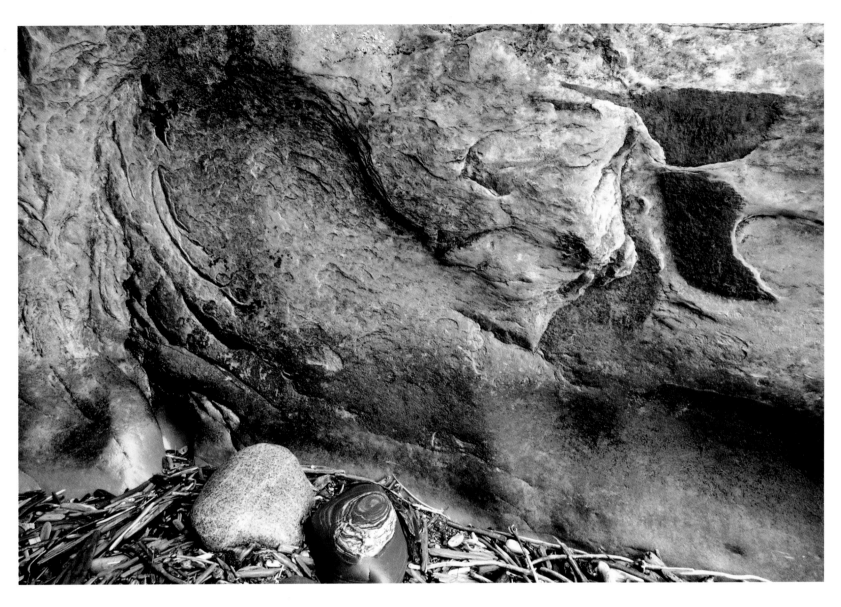

"Hummingbird Cave 2," Botanical Beach, BC, 1998

"Spirit Arc," sundog at Sombrio Beach, BC, 2000

Oh, to be still enough to hear and see and know the glory of the sky and earth and sea!

HUNDREDS AND THOUSANDS

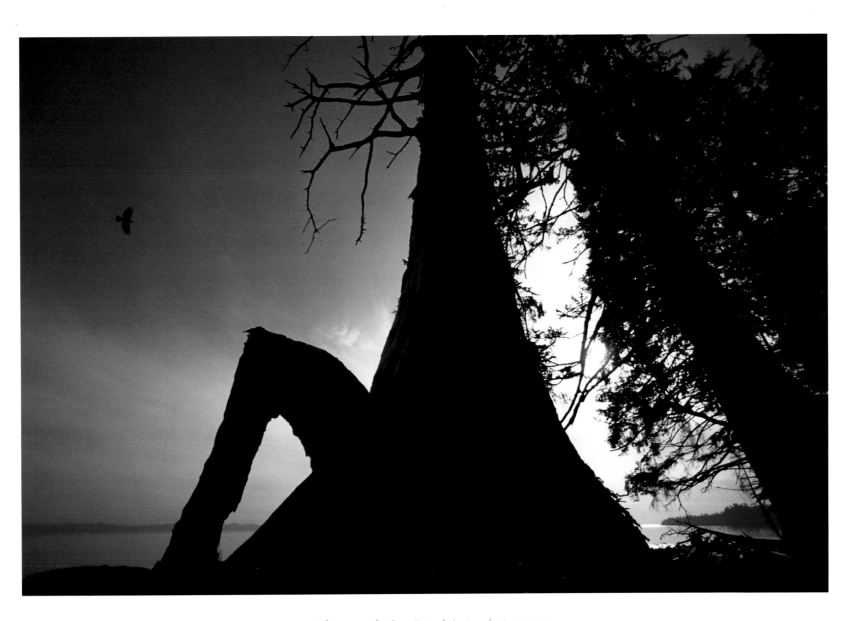

"Afternoon Shadows," Sombrio Beach, BC, 2000

"Survival," detail of rock, Sombrio Beach, BC, 2000

Once I used to think, "How would Lawren [Harris] express this or that?" Now I don't think that any more. I say, "Emily, what do you make of this or that?" I don't try to sieve it through his eye, but through mine. . . . I want the big thing but even if it never comes satisfactorily in paint, the trying for it is worth while.

HUNDREDS AND THOUSANDS

"Coastline," detail of marble table-top, Vancouver, BC, 1988

"River Gold," submerged rocks, Sombrio River, BC, 2000

"Sombrio Palette," reflections, Sombrio River, BC, 2000

"Mystery," camera motion on trees, 1986

Touching the Mystery

THE TABERNACLE WOODS

*"Dear Mother Earth! I think I have always specially belonged to you. I have loved from babyhood
to roll upon you, to lie with my face pressed right down on to you in my sorrows. I love the look
of you and the smell of you and the feel of you. When I die I should like to be in you uncoffined,
unshrouded, the petals of flowers against my flesh and you covering me up. . . . Oh, Mother Earth,
may I never outgrow the wholesomeness of your dear smell and flavour!"*

HUNDREDS AND THOUSANDS

By the time I had completed the fourth Soul of the Landscape workshop at Point-
No-Point (in May 2000), *Emily Carr Country* was already a glint in the eye of both
publisher and photographer. I was now sensing the forest in quite a different way
than I had before, either in the early days at Pacific Rim or during previous years at
Point-No-Point. I was learning to slow down, to be completely centred in my body, and
in touch with the richness and vastness of each moment. Until one has actually experi-
enced this deep centredness — been fully alive and at peace with the reality of here and
now — it is difficult, perhaps impossible, to know what I am referring to.

If this seems strange, or if it seems so obvious that it doesn't need saying, I invite
you to try a simple experiment: sit erect, either on the floor or upright on a chair
without back support. Close your eyes and allow yourself to think of nothing for five
minutes — just be a passive receptor to whatever you experience. Unless you are a highly
experienced meditator, it can't be done. Your mind almost immediately takes over and

runs the show. It takes you to other places, into memory, into the future, into lists of things that need doing, into physical discomfort such as an itchy nose or a cramped leg, or into a longing for stimulation.

Someone who has spent much time alone, not in front of a TV, but within the calming embrace of nature, would find this meditation much easier. I believe that those workshop participants mentioned in the previous chapter, sitting on a log, with the rhythms of the sea and the cry of the gulls, were perhaps unknowingly tuning their own frequencies to that of the beach. Certainly the change was to a slower, calmer place, with less scattered energy. The act of making photographs, in silence, became a richer, more nourishing experience that may even have resulted in more evocative images.

Now that I had the book *Emily Carr Country* in mind, I could return to the forest and revisit Emily's descriptions, this time, I hoped, with a deeper appreciation for what she was struggling to achieve. Her summer camps in her caravan, what she called the Elephant, allowed her to savour her surroundings in a way most of us can only imagine. It's little wonder she expressed so much frustration. She became so well attuned to the life and lustre of her "tabernacle in the woods" that it was virtually impossible for her to communicate the experience satisfactorily in either her paintings or her prose.

When I went back to her journal it began to make more sense to me: "The woods are brim full of thoughts. You just sit and roll your eye and everywhere is a subject, thought, something saying something." The trick in meditation is not to push but rather to stop pushing and let it happen. The same applies to being receptive to the soul or spirit of the forest. Emily writes, "Don't force it to come to you – your way – but try to adapt yourself to its way. Let it lead you." She could have added here, "In order to be led you must be perfectly still, totally in the moment, fully present with all your senses tuned to a heightened sense of awareness."

It wasn't enough for Emily to make trips to her enchanted forest; she needed to live within and mingle with the elements. That's why her trailer was so right as her base camp. She could spend countless hours absorbing the rhythms, soaking in the sights, touching the magic, smelling the mystery, her ear to the ground and her eye to the heavens. One of her most revealing passages on the importance of living in nature is when she compares her idyllic life in the trailer with that of her two sisters: "It would not give

them a spacious joy to sit at a little homemade table writing, with three sleeping pups on the bunk beside me, a monkey on my shoulder, and the zip and roar of the wind lifting the canvas and shivering the van so that you feel you are a part and parcel of the storming yourself. That's living! You'd never get that feel in a solid house shut away securely from the living elements like a barricade!"

Just as our workshop participants had a deeper, more rewarding experience immersing themselves in the "living elements," so Emily was clear that the grand prize was not the perfect painting (although she strove for it) but the joyous uncompromised pursuit of it: "I want the big thing but even if it never comes satisfactorily in paint, the trying for it is worthwhile."

Each time I plant my tripod in the forest, or swivel my camera to portray the movement of light, I try to focus not on the trees but on what Emily calls "the big picture." I strive to portray that intangible something that is the forest but not *that* forest. I want to look somehow beyond the trees to life itself, to qualities of light, growth, protection, diversity, balance and the harmonious interplay of the elements. To do so I must first feel that heightened arousal of the senses that comes from a place deep within me. That meditative or altered state is easier to achieve for me than it used to be, and easier to identify once I am there.

In the early days of my landscape work I sometimes found that I far preferred to photograph alone than to have others around me. If perchance I was disturbed by someone coming upon me quickly, or suddenly asking me a question, I would experience an unpleasant jolt like being woken from a dream. I could be quite abrupt with the person but not know why I was being so rude. I have come to understand the importance of being alone, and now take measures to avoid these interruptions. I realize now that by being fully absorbed by what I see in the viewfinder and by identifying with the setting while unconsciously jockeying the camera in order to compose is an extremely effective way of connecting more deeply with nature.

Even if a given photograph doesn't seem to reflect this elevated awareness, the cumulative effect of daily camera meditation does inevitably produce a stronger body of work. I am also convinced that I am actually having an out-of-body experience, because all or most of my awareness resides at the other end of the lens, participating in another identity.

"Sunlit Glade," multiple exposure on forest, 1995

It is curious that Emily does not write about taking time to meditate or having a daily routine to care for the soul. I suspect that her entire interplay with nature was her form of meditation, just as my connection to the spirit world has come through many years of peering through the viewfinder long before I began a practice of daily meditation. I find it amusing and immensely ironic that had Emily signed up for our Soul of the Landscape workshop she would probably have been the sole renegade choosing Adele's option at the fork in the trail and doing her meditation eyes wide open!

What I am sure of is that Emily Carr, however she accomplished it, had an uncanny ability to feel the pulse of the living forest and to form an amazingly intimate bonding with her surroundings. As one admirer put it, "I'll bet she could see energy." Her earlier paintings do not particularly portray her awareness of the life force, but much of her later work does, despite her modest objections that they were nothing but "dead paint."

It is the suggestion of the universal or ethereal forest, a place that is more within us than outside of us, that is the commonality in our respective work. If we can look at an image, whether it be a painting or a photograph, and say, "That's how I sometimes feel when I experience nature," then the artist has been successful. In the 1920s and 30s, Emily's audiences were slow to respond to her way of seeing because it conflicted with their expectation that painting ought to show the world as it is. Similarly, the pervasive present-day view of photography is that it ought to record outer reality. But I invite you, particularly on the following pages, to ask yourself not what these photographs represent or where they were made, but rather what quality of experience they take you to in your quieter moments.

"Enchantment," camera motion on forest, 1995

I feel that there is great danger in so valuing and looking for pattern and design as to overlook the bigger significance, Spirit, the gist of the whole thing. We pick out one pleasing note and tinkle it regardless of the whole tune. In the forest think of the forest, not of this tree and that but the singing movement of the whole. I suppose that is what the abstractionists are trying to do, boil the thing down to a symbol, but that seems to me rather like cutting a flower out of cardboard. The form may be correct but where's the smell and the cool tenderness of the petal?

HUNDREDS AND THOUSANDS

"Spirit Presence," camera motion on trees and ferns, 1988

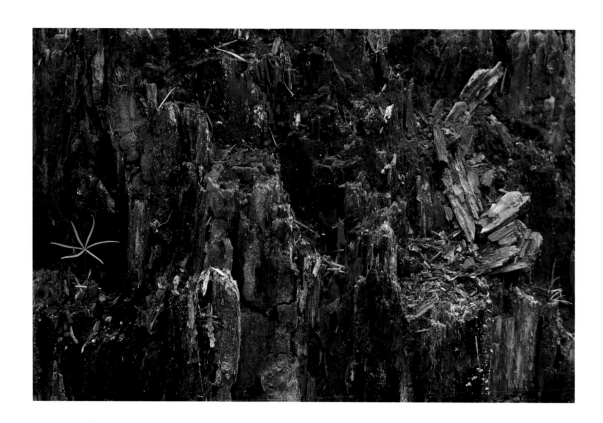

"Decaying Stump with Seedling," China Beach, BC, 2000

Slowly things begin to move, to slip into their places. Groups and masses and lines tie themselves together. Colours you had not noticed come out, timidly or boldly. In and out, in and out your eye passes. Nothing is crowded; there is living space for all. Air moves between each leaf. Sunlight plays and dances. Nothing is still now. Life is sweeping though the spaces. Everything is alive. The air is alive. The silence is full of sound. The green is full of colour. Light and dark chase each other. Here is a picture, a complete thought, and there another and there . . .

HUNDREDS AND THOUSANDS

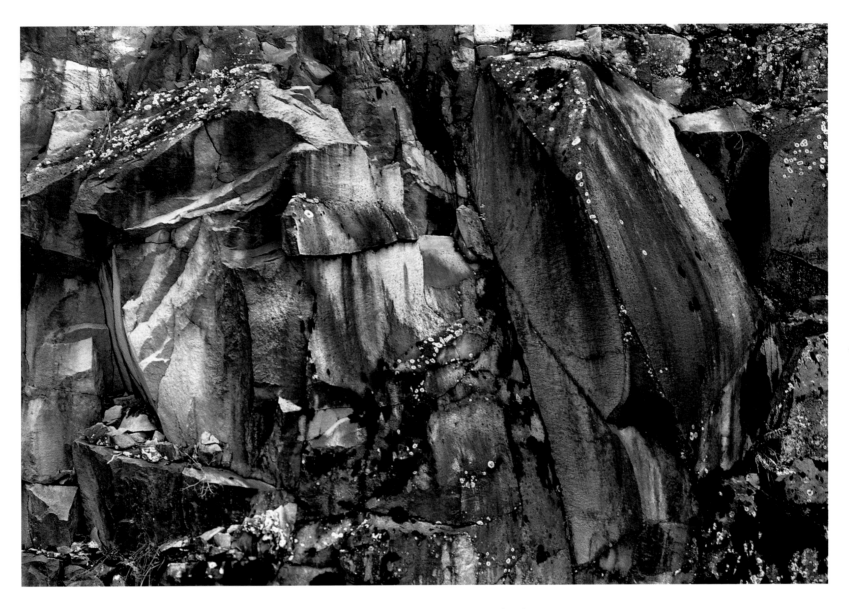

"Rock Ledge," Kennedy River, Vancouver Island, BC, 1983

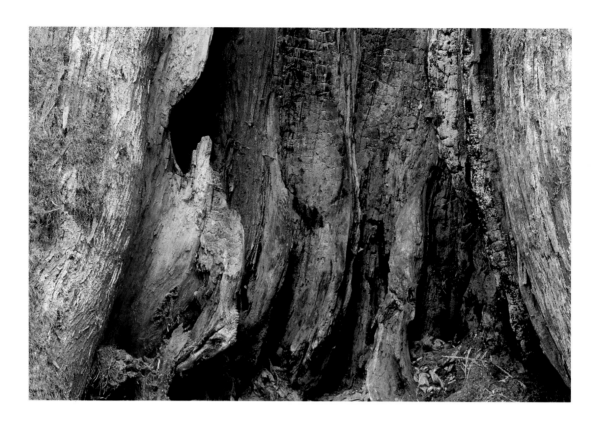

"Survivor," fire-damaged cedar trunk, Goldstream Provincial Park, BC, 2000

I want to express growing, not stopping, being still on the move. These subjects are stumps and pines and space. They are difficult to express, but my feeling is if one can see the thing clearly enough the expression will follow. The thing is to be able to apprehend things, to know what we are trying to get at, to know what we see. So many of us open our flesh eyes but shut the eyes of the soul.

HUNDREDS AND THOUSANDS

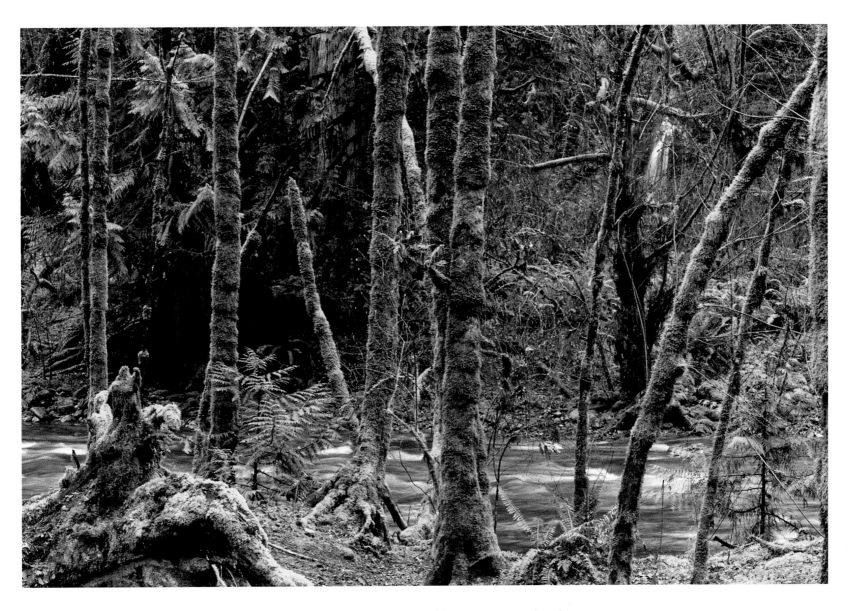

"Clearing," moss-covered maples at Goldstream Provincial Park, BC, 1987

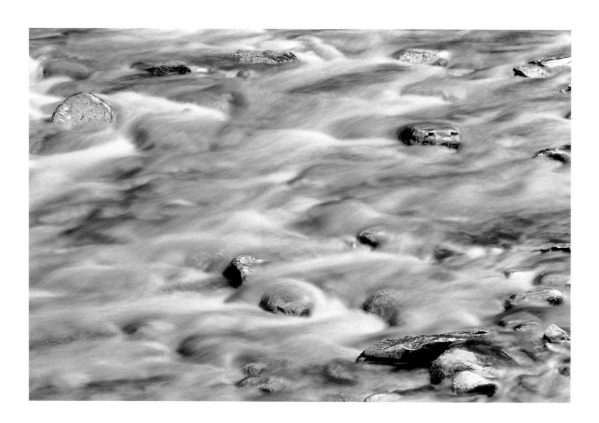

"Rapids and Rocks," Goldstream Provincial Park, BC, 2000

Now for my bath, or rather, dabbing three pores at a time in a small receptacle. After the whole surface has been dabbed you take a vigorous scrub with a harsh scrub brush. How much more sensible it would be to roll naked in this soft, sopping grass, a direct-from-heaven tub. Maybe in a former state I was a Doukhobor. The *liveness* in me just loves to feel the *liveness* in growing things, in grass and rain and leaves and flowers and sun and feathers and fur and earth and sand and moss. The touch of those is wonderful.

HUNDREDS AND THOUSANDS

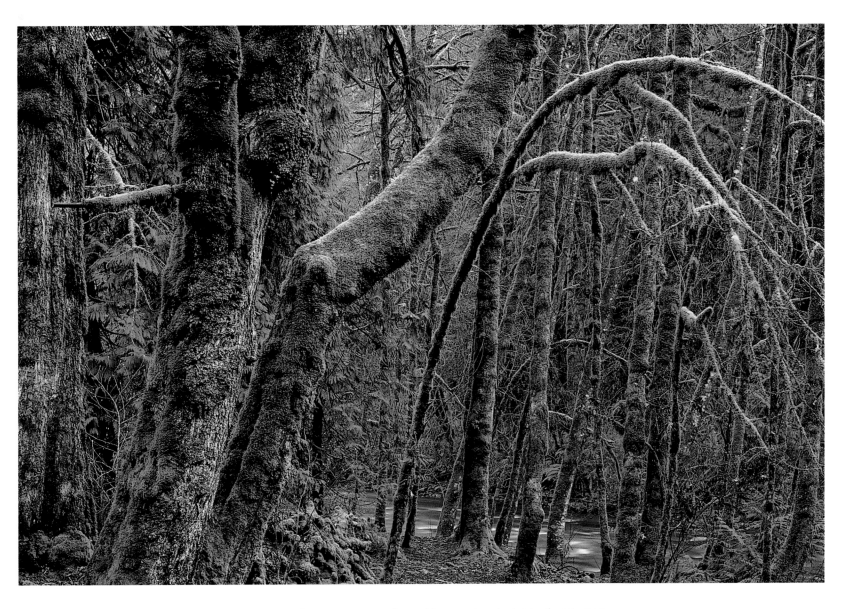

"In Mourning," moss on maples, Goldstream Provincial Park, BC, 1987

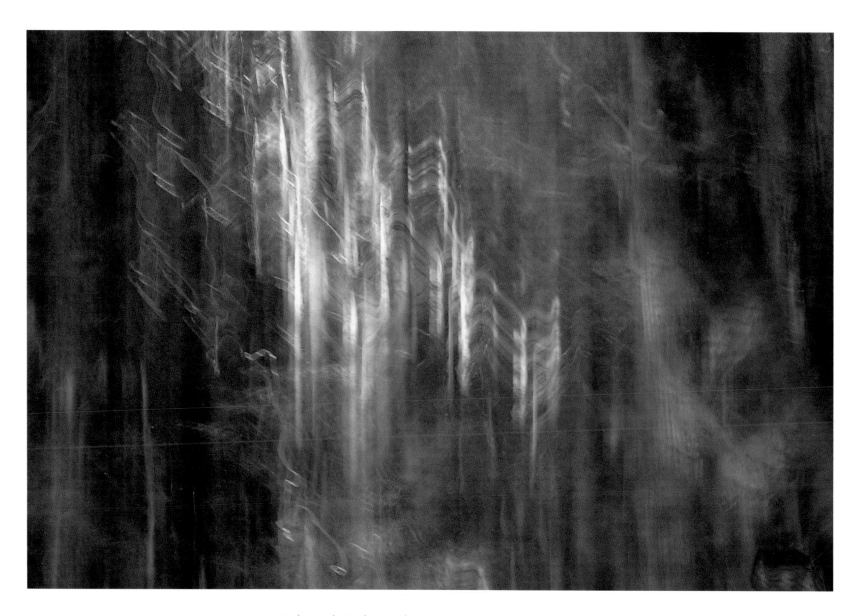

"Tabernacle in the Wood," camera movement on trees, 1998

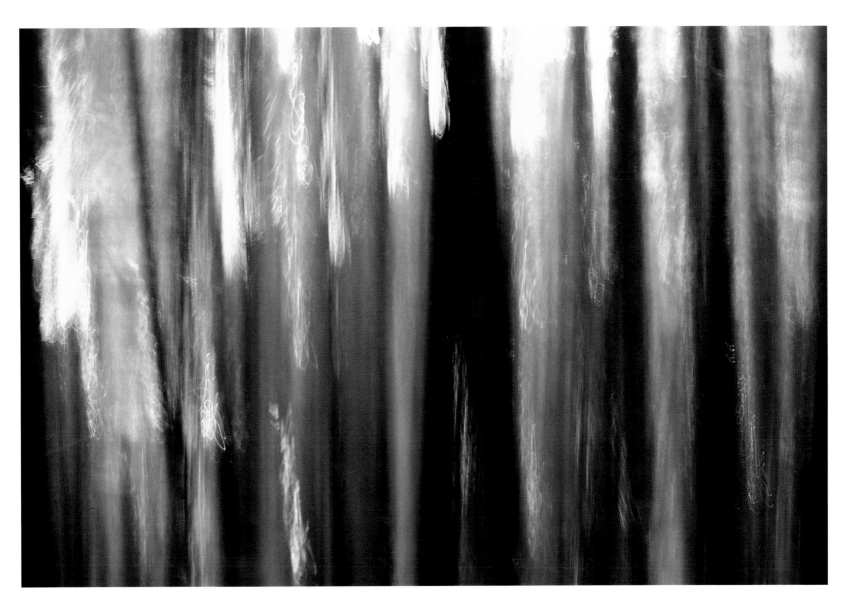

"Forest Harmonics," camera movement on tree trunks, 1997

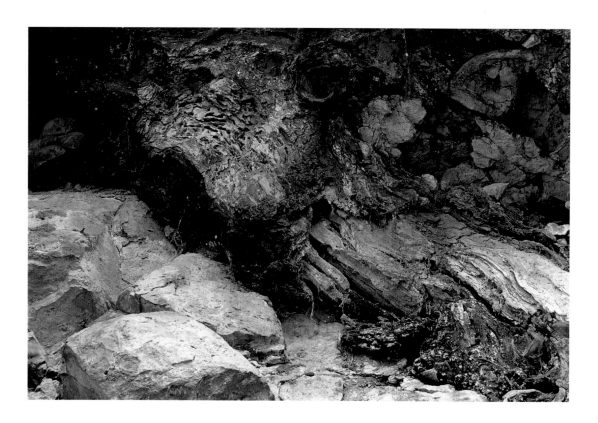

"Watchful Eyes," Stanley Park, Vancouver, BC, 1998

Sketching in the big woods is wonderful. You go, find a space wide enough to sit in and clear enough so that the undergrowth is not drowning you. Then, being elderly, you spread your camp stool and sit and look round. "Don't see much here." "Wait." Out comes a cigarette. The mosquitoes back away from the smoke. Everything is green. Everything is waiting and still.

HUNDREDS AND THOUSANDS

"Heart of the Woods," camera motion on spruce trunk, 1985

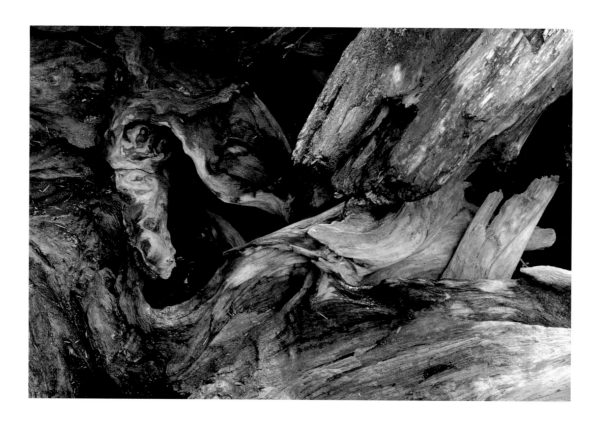

"Confrontation," driftwood detail, Botanical Beach, BC, 2000

I must go into my closet and shut the door, shut out Henry and camp cooking and visitors and food and drink and let the calm of the woods where the spirit of God dwells fill me, and these ropes that bind my hands and the films before my eyes fade away, and become conscious of the oneness of all life, God and me and the trees and creatures. Oh, to breathe it into one's system deeply and vitally, to wake from sleep and to live.

HUNDREDS AND THOUSANDS

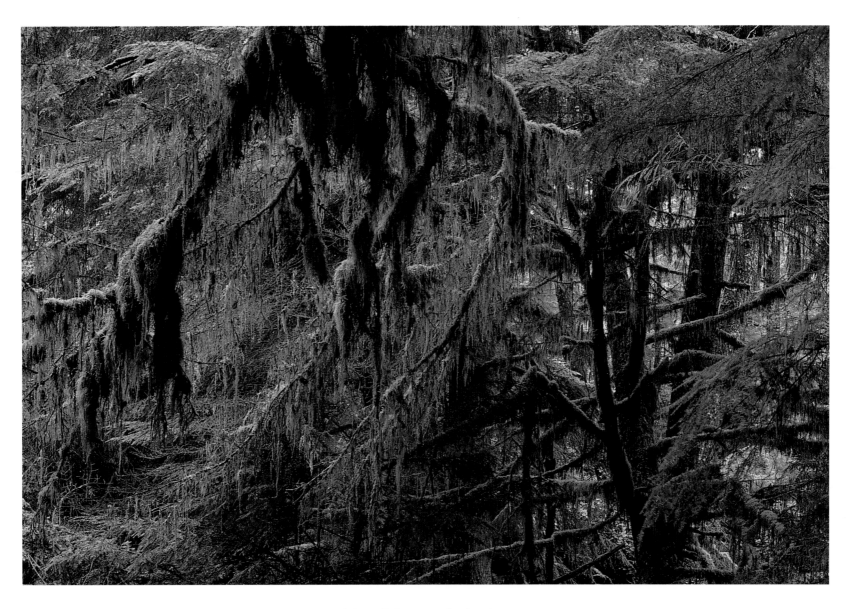

"Sobriety," lichen on cedar boughs, 1988

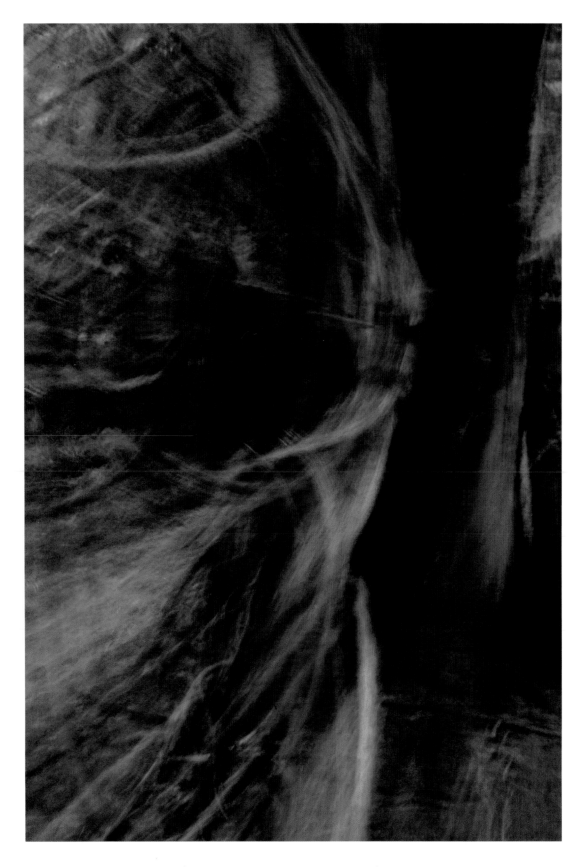

"Ghost Dance," camera movement on cedar, 1988

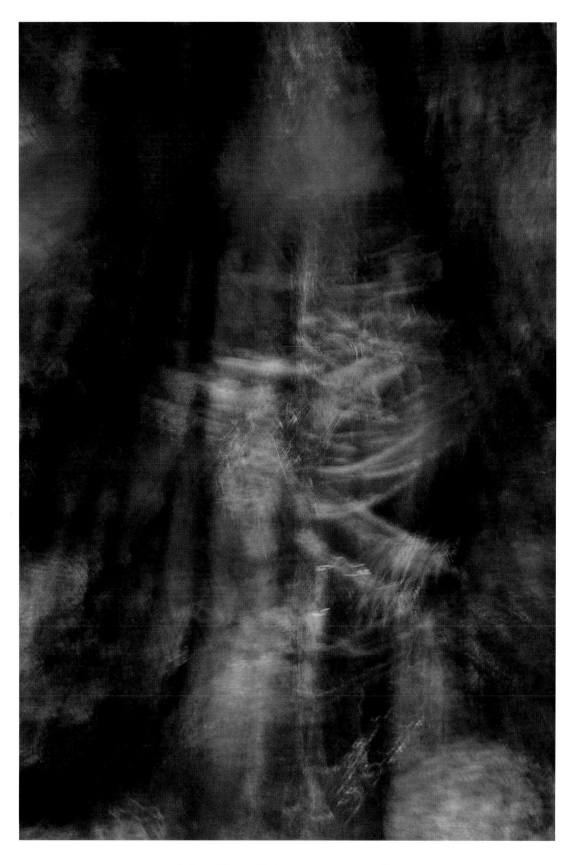

"Beyond the Veil," multiple exposure on cedar limbs, 1988

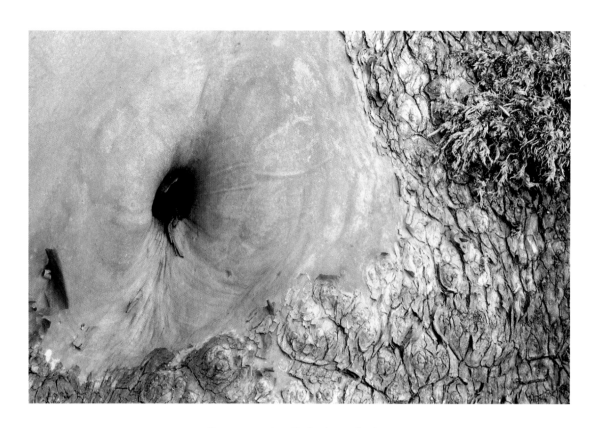

"Belly Dancer," detail of arbutus bark, 1998

Day was splendid – sunshine and blue, blue sky, and arbutus with tender satin bark, smooth and lovely as naked maidens.

HUNDREDS AND THOUSANDS

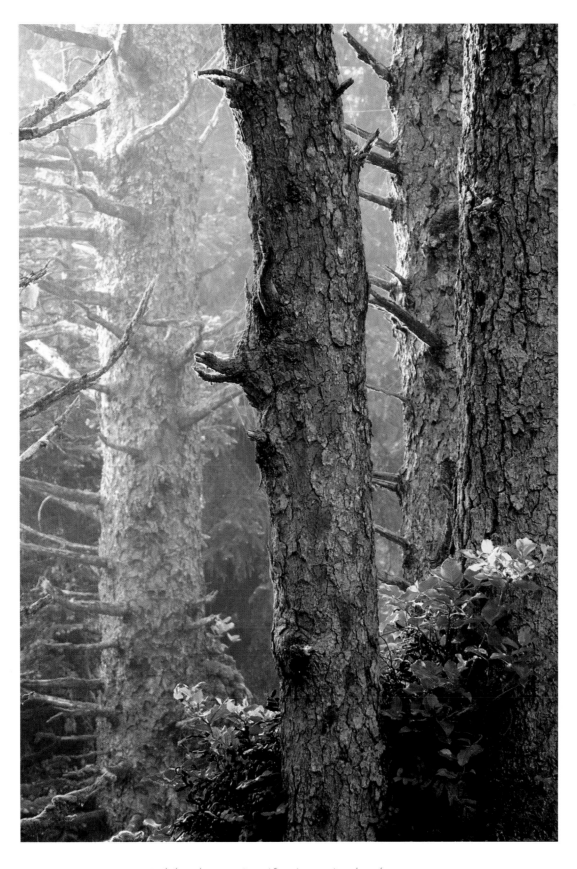

"Salal and Spruce," Pacific Rim National Park, BC, 1986

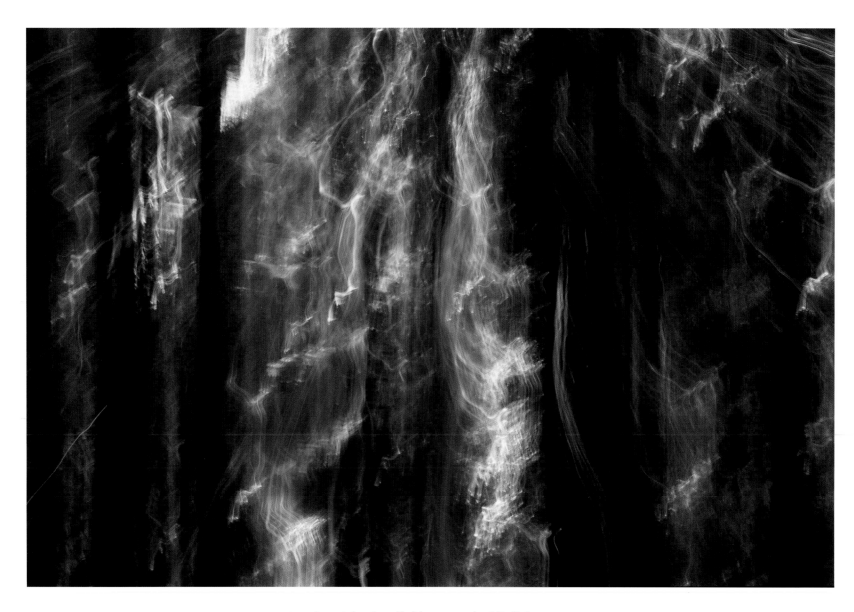

"Restless Light," handheld zoom on backlit lichen, 1997

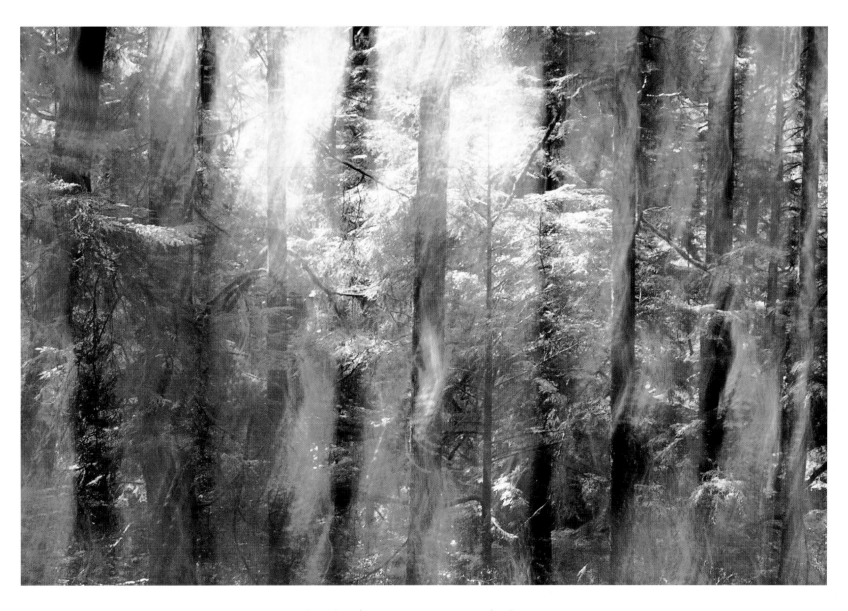

"Ethereal Light," camera motion on cedar forest, 1998

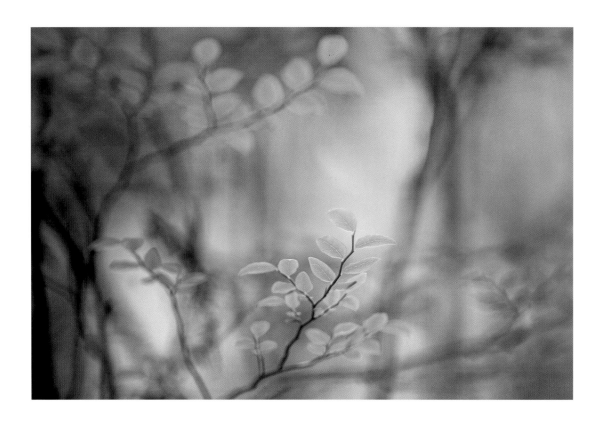

I run back into the woods with their serene perplexities, their fathomless deeps and singing fresh green tips. These days when the sun is bright they just chuckle with glory and joy.

HUNDREDS AND THOUSANDS

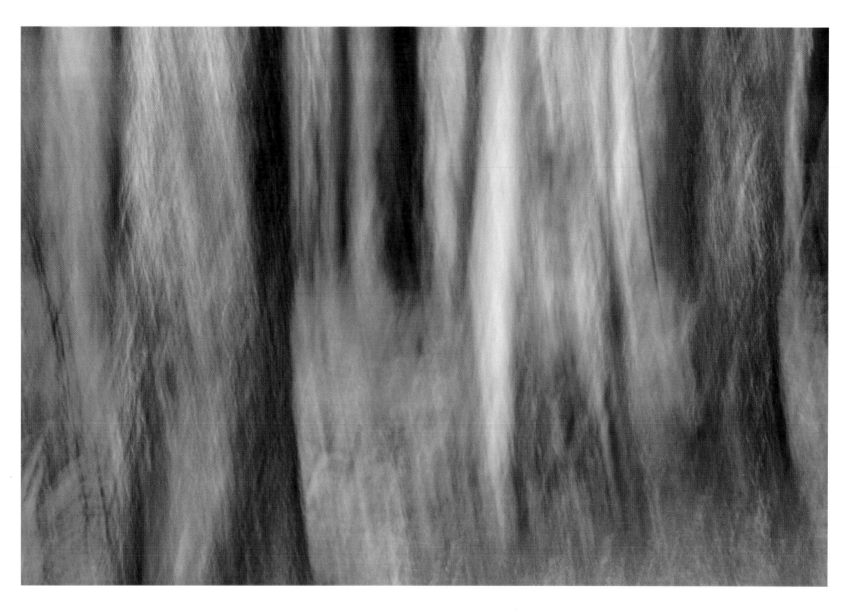

"Ascension," camera motion on fir and cedar, 1995

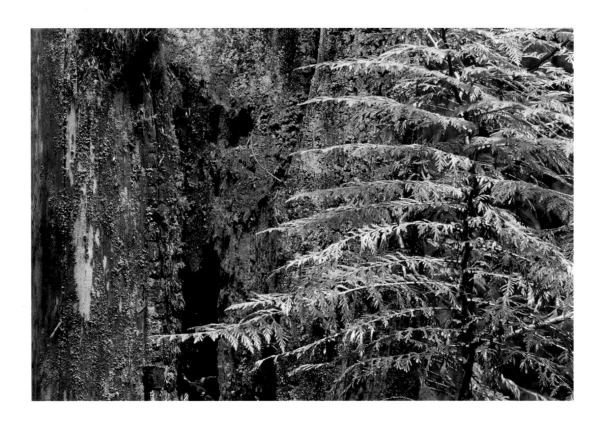

"Young Cedar," Francis/King Regional Park, Victoria, BC, 2000

There are themes everywhere, something sublime, something ridiculous, or joyous, or calm, or mysterious. Tender youthfulness laughing at gnarled oldness. Moss and ferns, and leaves and twigs, but only apparently tied up in stillness and silence. You must be still in order to hear and see.

HUNDREDS AND THOUSANDS

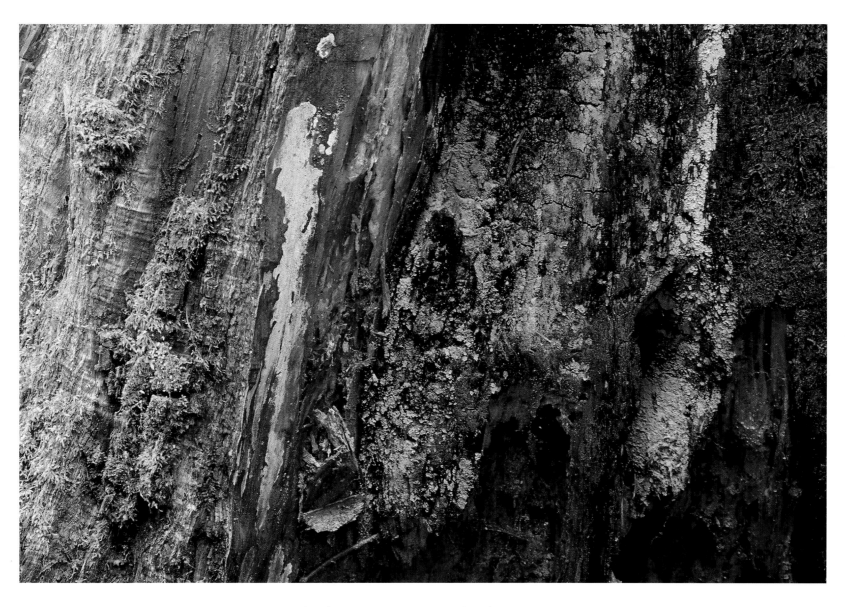

"Ravaged Cedar," Francis/King Regional Park, Victoria, BC, 2000

"Beyond the Grasp," view from Top of the World Highway, Yukon, 1988

Reaching Beyond the Grasp

VENTURES NEAR AND FAR

*"Every artist I meet these days seems to me to leak out the fact that somewhere inside
him he is groping religiously for something, some in one way, some in another, tip-toeing,
stretching up, longing for something beyond what he sees or can reach."*

HUNDREDS AND THOUSANDS

One need only peruse the titles of Emily Carr's paintings to identify many of
the settings to which she had been drawn — Stanley Park, Skagway, Sitka,
Kitwancool, Lillooet, Masset, Pemberton, and Cariboo Country — to cite a few.
Many of her earlier travels were to Native villages, often difficult to reach, while much
of her later work portrayed places of natural beauty and spiritual power.

When I began my quest to photograph sacred places in 1987, my passion was to
experience locations of great attraction overflowing with primal energy and grandeur.
Sometimes these places were bold and forthright, commanding reverential attention —
great monoliths and cliffs, for example, thrusting from the valley floor. Other places were
discreet and nourishing. Other spots were natural sanctuaries where I felt protected from
the elements as well as from the clamour of the human world. As I look back at the
evolution of my interest in the sacred, I am struck by the opposite directions that
we travelled in our respective quests. I was first drawn to all things natural, and only

later allowed human artifacts to appear in my compositions (though the mortuary poles at Ninstints actually represent my first and only attempt for many years to photograph archeology of any sort). Emily, on the other hand, began with a fascination for the totem artwork, almost to the exclusion of everything else, and then later moved on to the landscape as an expression of the sacred partly due to the crucial support and encouragement of Lawren Harris. Harris wrote to her, "I feel that you have found a way of your own wonderfully suited to the expression of the Indian spirit and his feeling for life and nature. . . . The pictures are works of art in their own right, individual, finely plastic and having creative life in them. I have nothing to say – save this – don't be influenced by anything or anybody. Shun everything but your own inner promptings, your own pure reactions – like the plague."

When I set out specifically to explore some of Emily's destinations, I discovered a great diversity of terrain, and to a large degree inland British Columbia today still contains vast areas of untouched, albeit threatened, wilderness. It still has the capacity to stir the heart and stimulate the mind as it did for her, the first time a hundred years ago and again in the 1930s. It was easy to see as I gazed up at the last light, cherry-red on the snow-capped peaks northeast of Pemberton, why she was so enthralled with this high country. I travelled with my stack of index cards, each with a neatly typed Carr quotation that not only reminded me of the geography that caught her eye but more importantly provided a personal tour around the byways of her inner landscape. Just as Lawren Harris had prodded Emily to "shun everything but your own inner promptings," so I felt Emily's spirit challenging me to discover my own connection with the land.

First, she took me on a train ride, describing the scenery as we snaked through the canyons on the Lillooet River: "Mountains towering – snow mountains, blue mountains, green mountains, brown mountains, tree covered mountains, barren rock, cruel mountains with awful waterfalls and chasms and avalanches, tender mountains all shining, spiritual peaks way up among the clouds." Reading again the passages that spoke of her excitement and passion for the landscape was whetting my appetite for some grand experiences of my own, and to try to express the allure on film. I would start by paying attention to the nuances of hues, simplifying my designs, sometimes by isolating only one or two colours and playing with the gradations of light.

One morning I rose early, well before the first hint of dawn, and made my way to a hillside a short distance north of Clinton. As the early light began to brighten, highlighting the ridges of the lower hills, the colours changed dramatically from dusty pink to flares of brilliant tangerine and ruddy brown. I switched to a longer zoom lens and played with tight compositions isolating only the barest of essentials. It is truly remarkable how intimate and charming these sparsely clad slopes become when singled out and perfectly framed in the viewfinder. They assumed a life of their own, a more intimate identity that invited me to get closer, to know more, to stay and to interact, despite having to face into a chilling wind. For a few brief seconds I was lost to the mountainside, ascending its naked slopes, with only a handful of stunted spruce and pine daring to venture beyond the treeline, then back into my body and the attendant reality of the moment — *click, click*. A slight adjustment of exposure — *click*, and *click* again.

The sun was striking the upper slopes now, and the shadow of the ridge opposite was clearly outlined as it shivered its way down the hillside and through the trees, leaving only bold sunlight in its wake. Then the entire hillside flickered like a candle, grew strong again, wavered, and died. The golden light that had given the mountain its morning glow did not come again. I turned and saw that a cloud front had drifted in from the north, obliterating the sun. The dawn spectacle had come to an end. I felt profoundly privileged to have been invited, an audience of one, to the grand light show on the hillside. With the valley cast into relative darkness, I realized that it was cold and windy and time to hunt for breakfast in town. As I sat in a cozy café, waiting for my food to arrive and feeling warmth return to my toes, I rifled once again through the quotations: "Oh, these mountains, great bundles of contradiction, hard, cold, austere, disdainful, remote yet gentle, spiritual, appealing! Oh, you mountains, I am at your feet — humble, pleading! Speak to me in your wordless words! I claim my brotherhood to you. We are of the same substance for there is only one substance. God is all there is. There is one life, God life, that flows through it all."

As I ventured farther into Emily Carr Country, my path unfolded in unexpected ways. On one occasion, during an earlier trip to Cariboo Country with Fred Chapman (one of my mentors mentioned in Chapter One), we had been photographing right through the day and into the night. As we hit the sack in his camper I made the mistake of telling him I was looking forward to sleeping in for a bit the next morning. I awoke

suddenly at six to find myself, mattress and all, flying across his camper and landing with a thud on the floor. I sprang up, wide awake, thinking we had been hit by a tornado. "Oh well," he muttered with a mischievous grin, "since you are up anyway, we might as well get out there and photograph." While he spoke he was already making my bed back into a bench, which we sat on to drink our coffee. It brought new meaning to the phrase "an early morning pick-me-up!" We tumbled out of the camper to greet a spectacular sky, even darker and more brooding than my mood. Within thirty seconds the ominous scene was on film and another full day of photography had been launched.

Like Emily, I, too, returned to the totems many years after my initial trip to Haida Gwaii. In 1994 Sherrill and I took her eighty-five-year-old mother, Dorothy, on a cruise of the Inside Passage to Skagway, Alaska. It was the same excursion Emily had made a little more than eighty-five years earlier. We discovered that Dorothy was retracing her own 1931 cruise of the Inside Passage, taken at a time when Emily, by then a mature artist, was returning to Indian villages along the west coast to continue recording the totems on canvas. I wonder if Emily and Dorothy ever came face to face. When we docked at Sitka I took the same "Totem Pole Walk" that Emily had ridiculed in her journal for being a contrivance for tourists, but I stayed on after the crowds dissipated and found my own corner for quiet contemplation. What impressed me was how the tall straight cedar poles seemed to mingle and blend with their living brothers and sisters. It felt as though their makers, by carving the spirit faces into the wood, had given them a new life, vibrant and towering. In some ways these magnificent artworks were even more alive than the surrounding forest as the totems reached skyward with dignity and purpose.

To visit places frequented by Emily makes me feel as though time has collapsed, especially when those places have maintained their power to embrace. But geography is only one way to approach Emily Carr country. Hers is also the world of metaphor and analogy. Many of her paintings stand as icons for the spiritual life. Her descriptions of nature are sprinkled with sage understanding, her writings with a dash of poetic flare — metaphors, similes, and personification abound. She loved repetition. "Snow mountains, blue mountains, green mountains, brown mountains" is articulated just as mountain domes repeat themselves again and again along the range. Another characteristic technique is the stringing together of a number of adjectives, each one evocative, dramatic, poignant, daring yet sensitive, insightful, descriptive! Thus my trip through British

Columbia and coastal Alaska was much more than tracing my way along a map. It was a rare and privileged opportunity to stimulate and challenge my vision, to clamber over my own rugged backcountry, pay homage to my own ancestral totems and learn more about my place in the great scheme of things. My purpose, particularly in this chapter, is to exhibit Emily's writings as a creative springboard, just as we did so regularly in the Tofino and Point-No-Point workshops.

A number of my photographs here were chosen not because they depict a place, but because they portray a mood or quality of expression that lends a new flavour to her narrative. Because she often sees her world metaphorically rather than literally, I feel inspired to portray my photographs as poetic partners rather than as geographic matches to her text.

"Time and texture faded . . . ceased to exist . . . day was gone, yet it was not night. Water was not wet nor deep, just smoothness spread with light." I read this passage again and again, trying to discern why it drew me so irrevocably. Then I realized that there was a poem, complete with rhyme and metre, buried in her prose:

Time and texture faded,
yet it was not night.
Water was not wet nor deep,
just smoothness spread with light.

Such transcendent words could only be combined with photographs suggesting a universality unlimited by context, time or place.

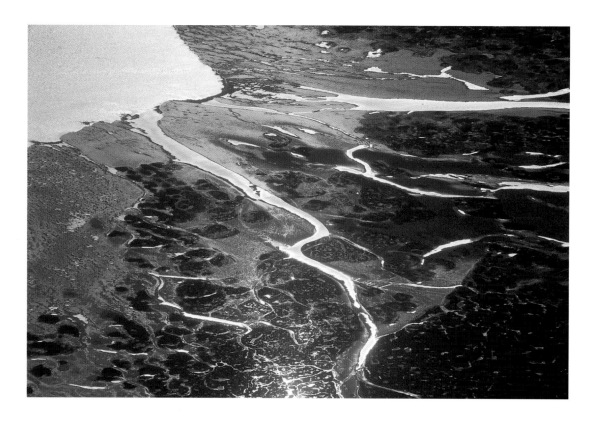

"Kluane Lake," aerial view, Yukon, 1987

My whole life is spread out like a map with all the rivers and hills showing.

HUNDREDS AND THOUSANDS

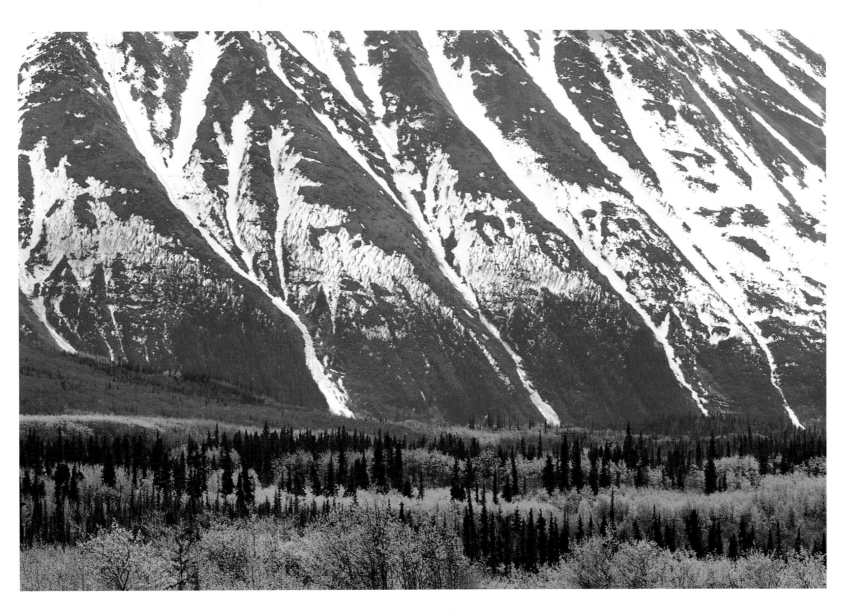

"Spring Snow," Yukon, 1987

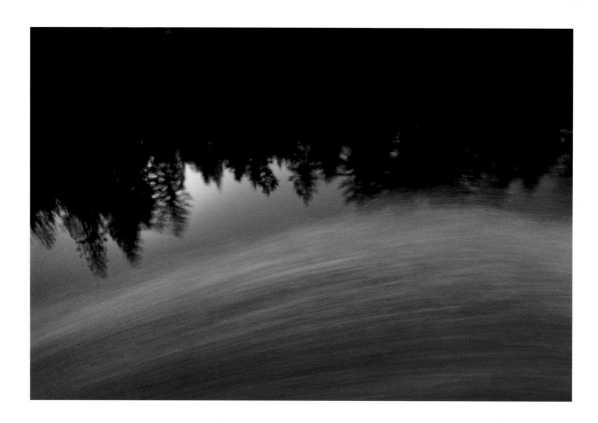

"Inverted Forest," tree reflections and bow spray, 2000

It was midnight when the wolf-like nose of our canoe nuzzled up top the landing at Alliford. All the village was dark. Our little group was silhouetted on the landing for one moment while silver passed from my hand to the Indian's.

"Good-night."

"Gu-ni'."

One solitary speck and a huddle of specks moved across the beach, crossed the edge of visibility and plunged into immense night.

Slowly the canoe drifted away from the moonlit landing, till, at the end of her rope, she lay an empty thing, floating among the shadows of an inverted forest.

KLEE WYCK

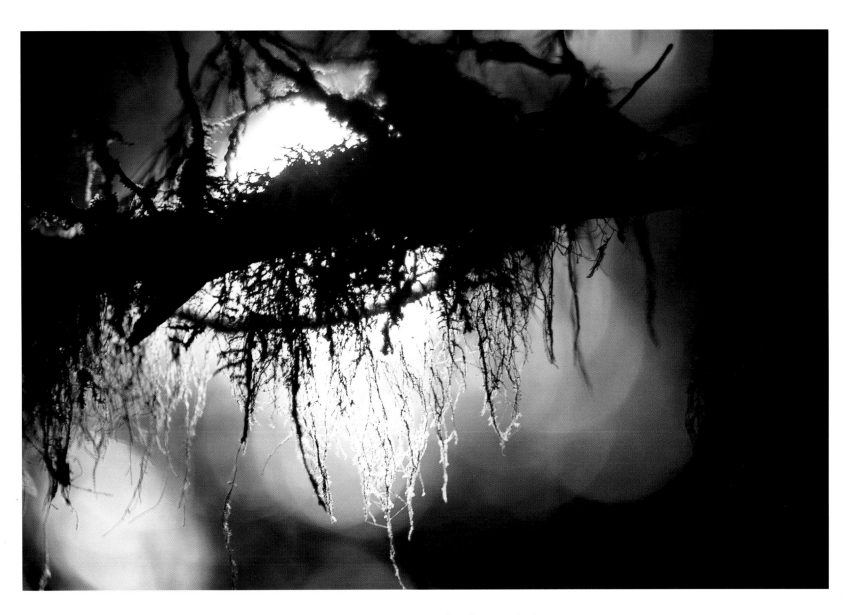

"Spell of the Moon," old man's beard on tree limb, 1986

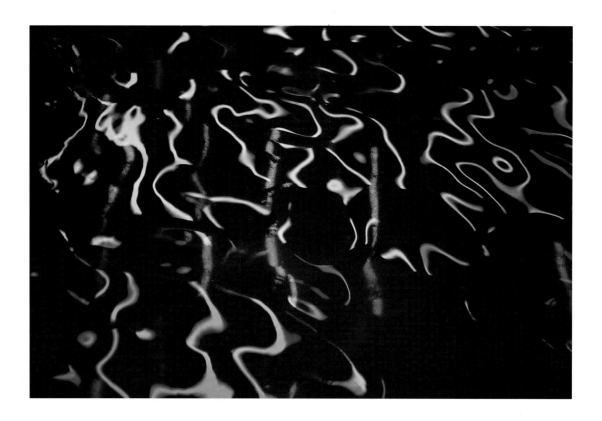

The canoe passed shores crammed with trees — trees overhanging stony beaches, trees held back by rocky cliffs, pointed fir trees climbing in dark masses up the mountain sides, moonlight silvering their blackness.

Our going was imperceptible, the woman's steering paddle the only thing that moved, its silent cuts stirring phosphorous like white fire.

KLEE WYCK

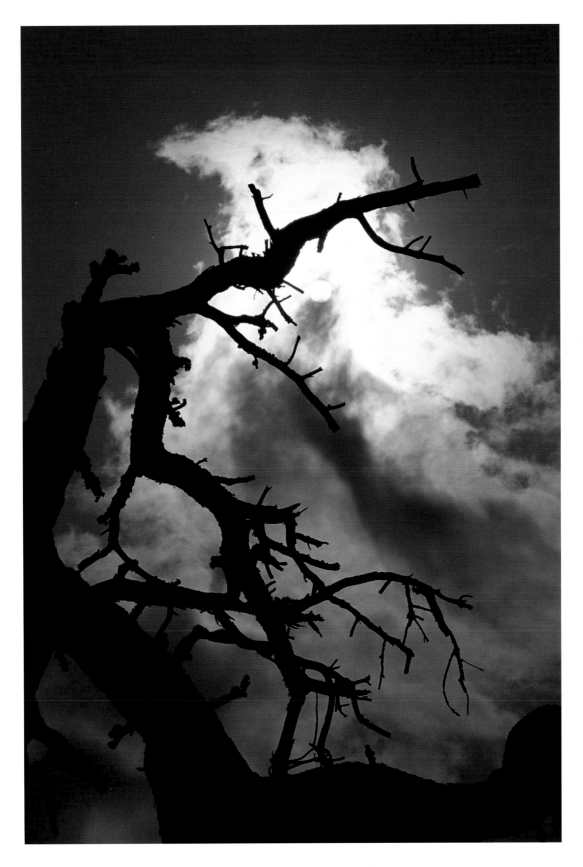

Enchanted," silhouette of dead tree, near Lillooet, BC, 2000

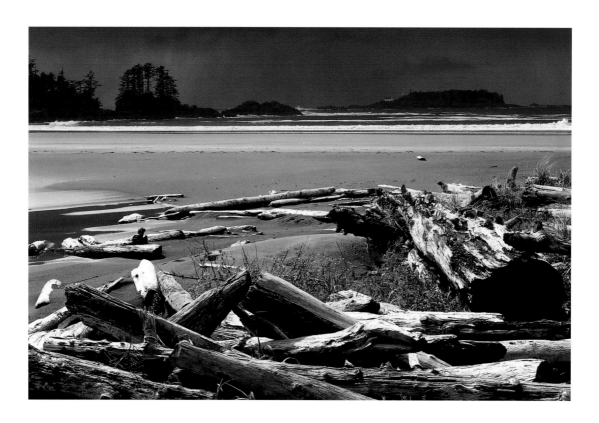

When in delicious remembering my mind runs back to Sitka, what does it see? Not the little old town with a long wharf approach straddling over mudflats, its final planks meeting the dirt roadway of Sitka's main street; not the quaint Russian church which is one of Sitka's tourist attractions; not Totem-Pole Walk winding through trees beside a stream named Indian River, named for the pleasing of tourists but really the farthest possible distance from the village of Indian shanties – a walk ornamented at advantageous spots with out-of-setting totem poles, transplanted from their rightful place in front of an Indian chief's house in his home village, poles now loaded with commercial paint to make curiosity for see-it-all tourists, termed by them "grotesque," "monstrous," "heathenish"!

THE HEART OF A PEACOCK

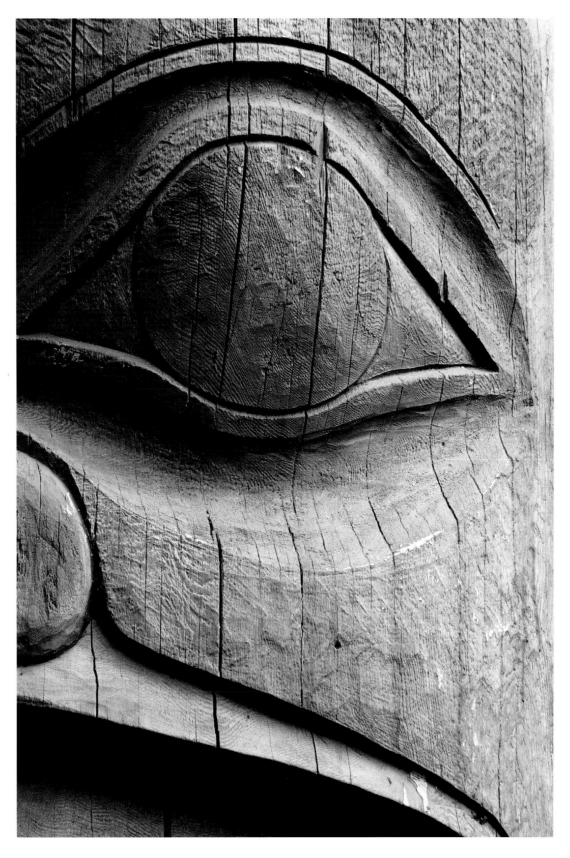

"Being Watched," detail of totem pole, Sitka, Alaska, 1990

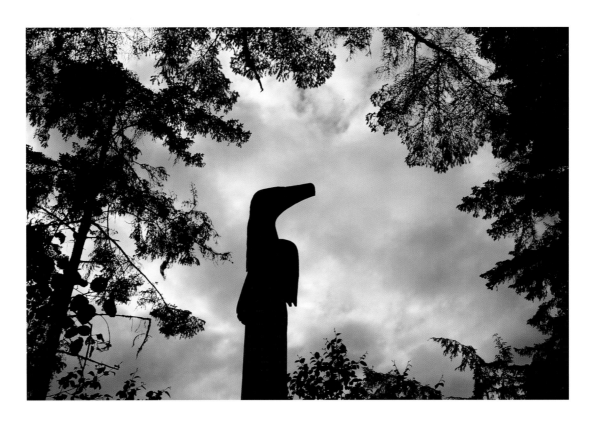

"Alone," raven carving on mortuary pole, Sitka, Alaska, 1990

Not far from the house sat a great wooden raven mounted on a rather low pole; his wings were flattened to his sides. A few feet from him stuck up an empty pole. His mate had sat there but she had rotted away long ago, leaving him moss-grown, dilapidated and alone to watch dead Indian bones, for these two great birds had been set, one on either side of the doorway of a big house that had been full of dead Indians who had died during a smallpox epidemic.

KLEE WYCK

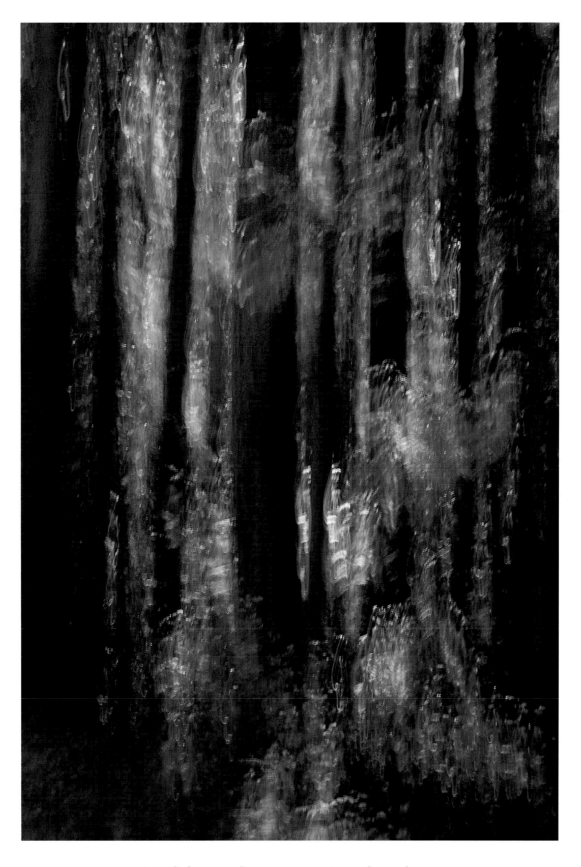

"Moonlight Descending," camera motion on fir trunks, 1986

"Tranquility," evening light on forest fire smoke, 1986

I thought my mountain was coming this morning. It began to move, it was near to speaking, when suddenly it shifted, sulked, returned to obscurity, to smallness. It has eluded me again and sits there, mean, puny, dull. Why? Did I lower my ideal? Did I carelessly bungle, pandering to the material instead of the spiritual? Did I lose sight of God, too filled with petty household cares, sailing low to the ground, ploughing fleshily along?

HUNDREDS AND THOUSANDS

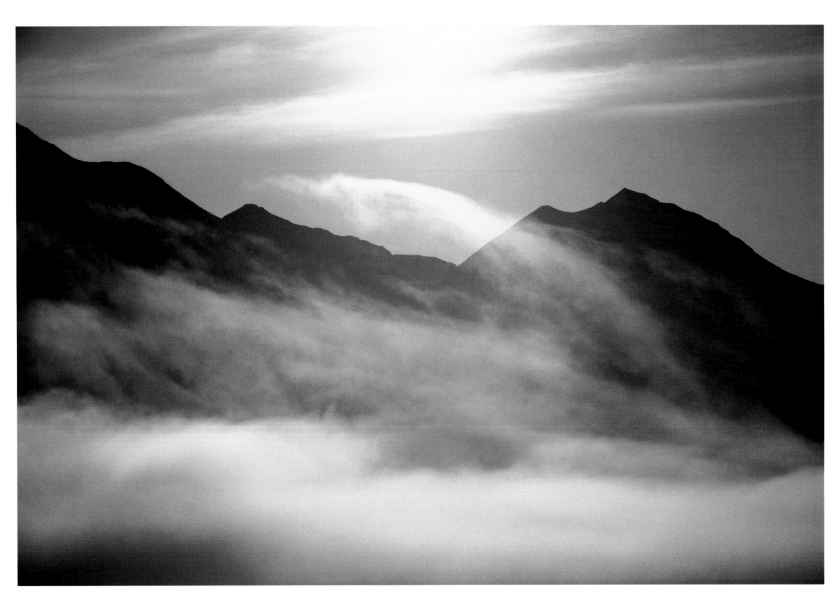

"Fog on Mountain Range," Haines Junction, Yukon, 1983

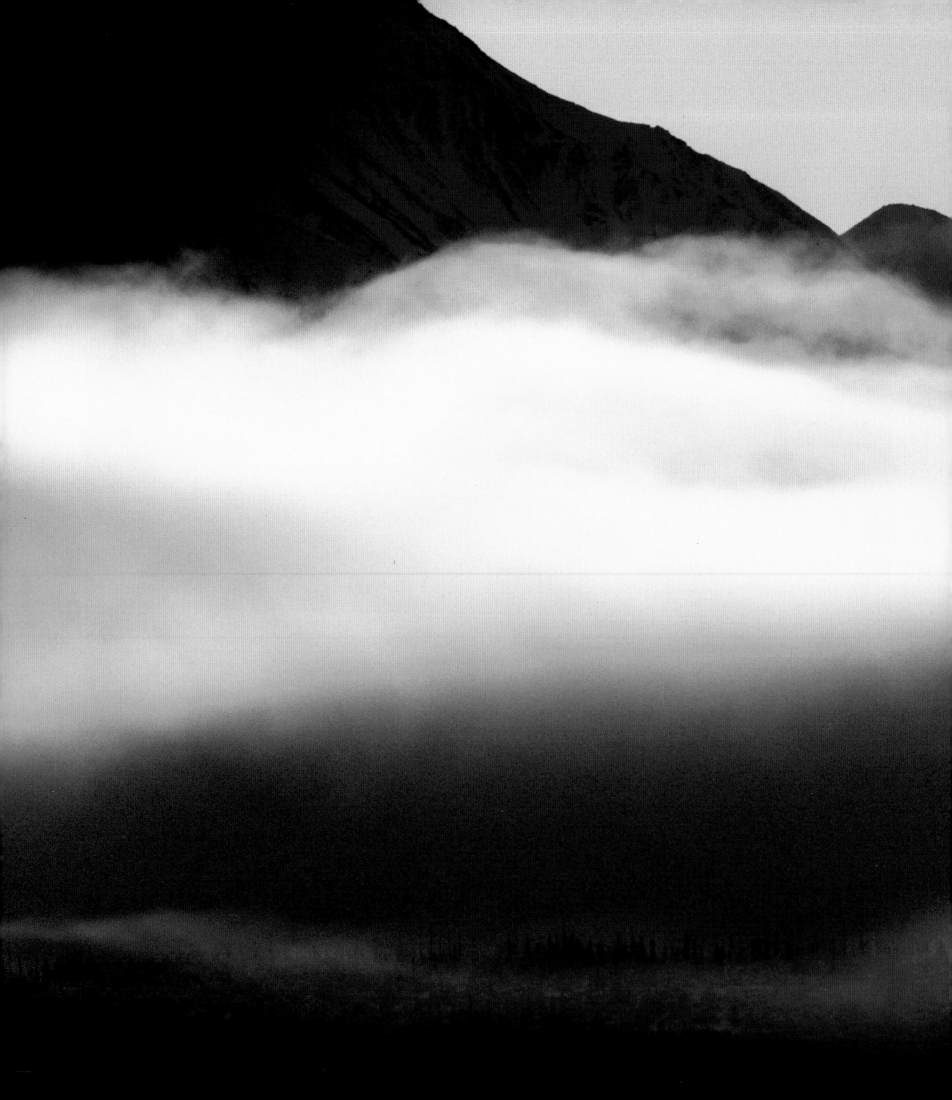

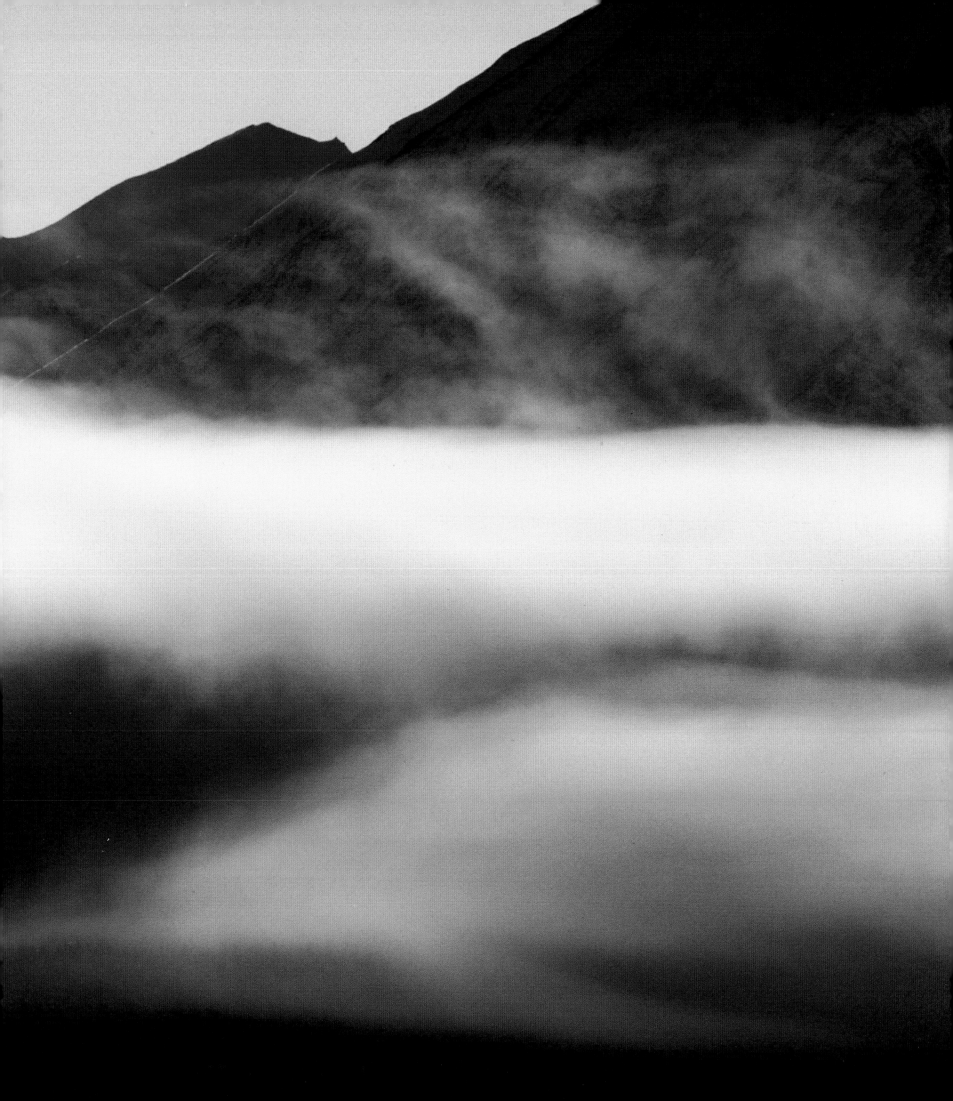

"Grizzled Hair," detail of drift log, Botanical Beach, BC, 2000

The fallen tree lay crosswise in this "nothing's place"; it blocked my way. I sat down beside the sawing Indian and we had dumb talk, pointing to the sun and to the sea, the eagles in the air and the crows on the beach. Nodding and laughing together I sat and he sawed. The old man sawed as if aeons of time were before him, and as if all the years behind him had been leisurely and all the years in front of him would be equally so. There was strength still in his back and limbs but his teeth were all worn to the gums. The shock of hair that fell to his shoulders was grizzled. Life had sweetened the old man. He was luscious with time like the end berries of the strawberry season.

KLEE WYCK

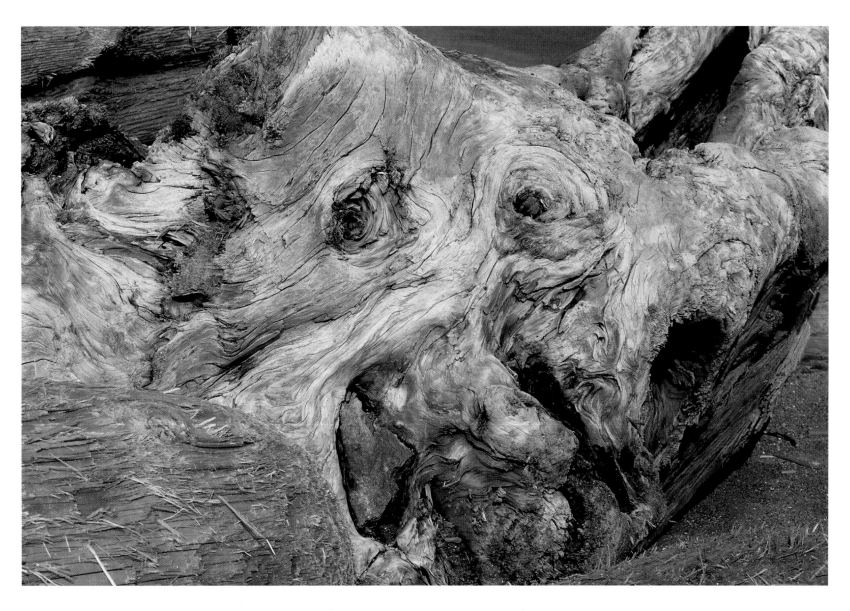

"Mellowed," drift log, Pacific Rim National Park, BC, 1986

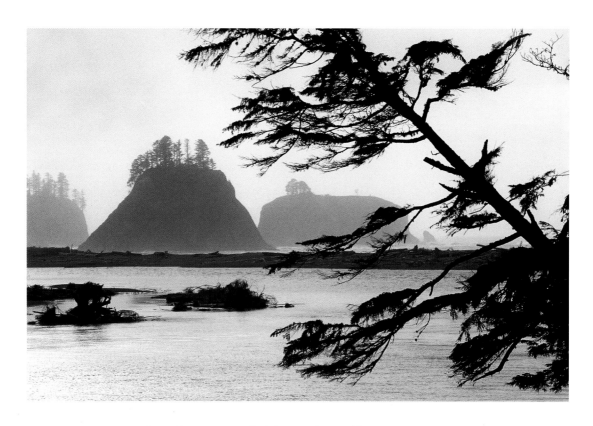

"Weather-torn Hemlock," La Push, Washington, USA, 1987

Where the sea had been was mud now, a wide grey stretch of it with black rocks and their blacker shadows dotted over it here and there. The moon was rising behind the forest – a bright moon. . . . An owl cried, and then a sea-bird. To be able to hear these close sounds showed that my ears must be getting used to the breakers. By and by the roar got fainter and fainter and the silence stronger. . . .

Dawn and the sea came in together. The moon and the shadows were gone. The air was crisp and salty. I caught water where it trickled down a rock and washed myself.

KLEE WYCK

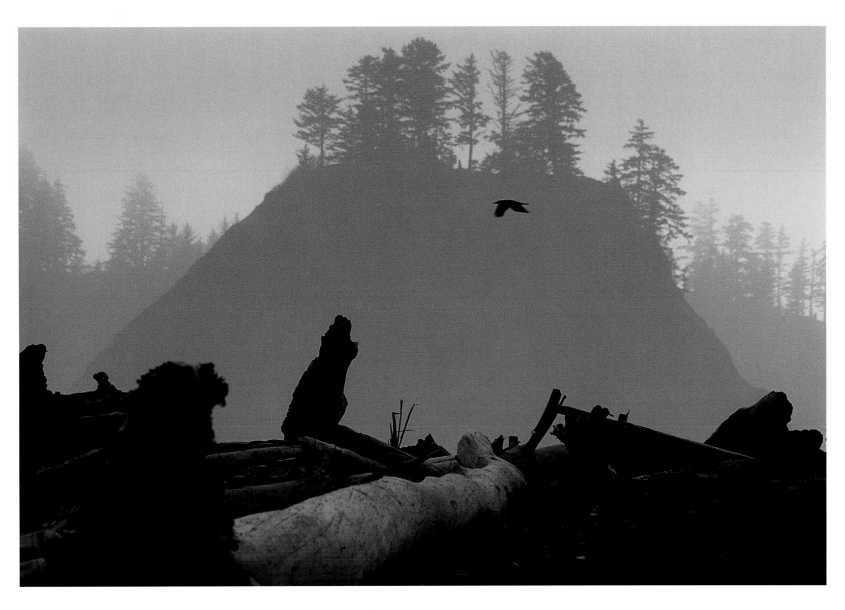

"Bird Watching," La Push, Washington, USA, 1987

"Nancy's Fire," woodstove, Highlands, Victoria, BC, 2000

When souls touch and commune, either silently or by speech, it is the keenest joy there is, I suppose. Perhaps in later lives we shall be sorted out not in physical families but in soul families. And we'll use soul talk, soul attributes, and put on soul growth. These human contacts and relationships are very difficult – so much misunderstanding, so much binding. Perhaps we should not heed the human relationships too strongly but look about among those we meet and contact and perchance recognise some soul relatives, people who have the same common ingredients as us.

HUNDREDS AND THOUSANDS

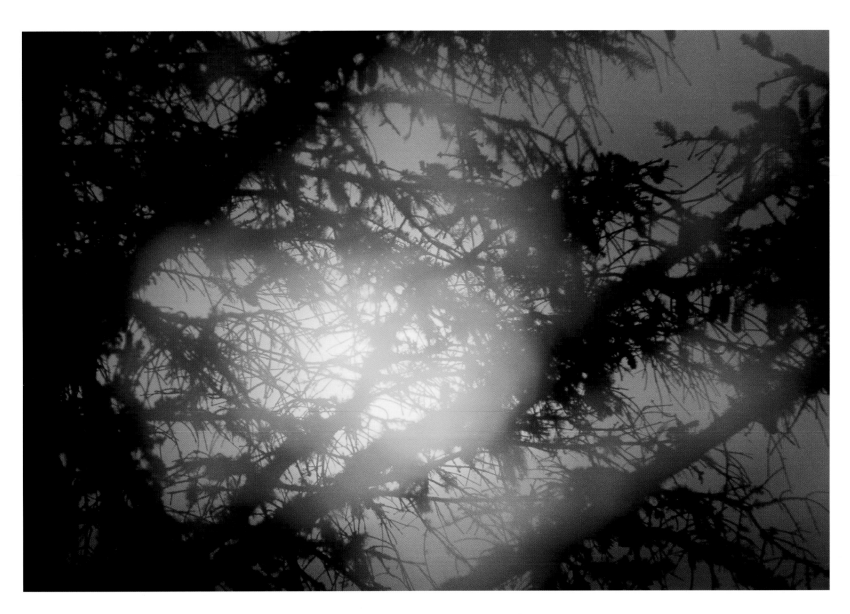

"When Souls Touch," sunrise through branches, 1987

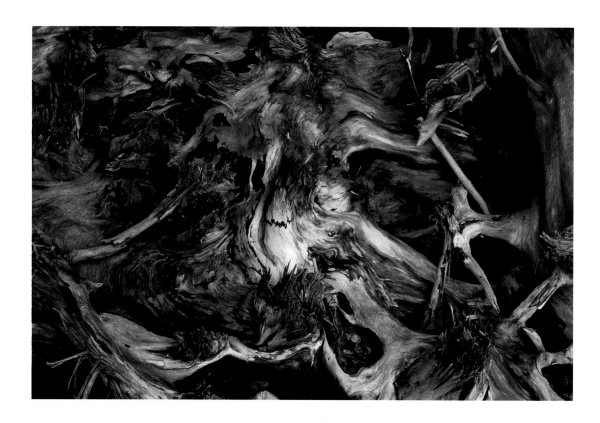

"Commune," roots of giant log, Botanical Beach, BC, 1998

Suddenly, in the middle of all the people and all the confusion of tumbling, unmeaning words, someone says, "Where's that?" And you lift your eyes to the painted husk and pass through it, out, out, ever so far, to the story that beckoned and urged you to try to express it. Then someone comes up and says, "What did you mean?" They want lettered words that can be rolled on the tongue. They can't understand you could not word those happy yearnings, those outgoings when the Supreme Spirit touches its child.

HUNDREDS AND THOUSANDS

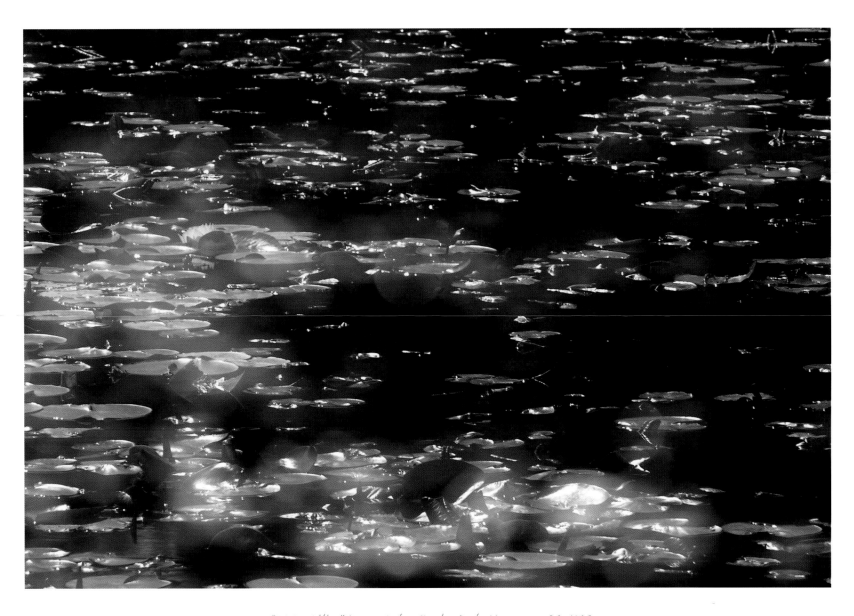

"Water Lilies," Beaver Lake, Stanley Park, Vancouver, BC, 1986

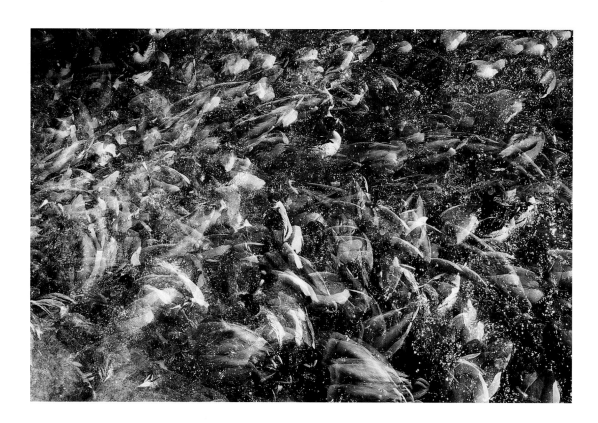

"Feeding Frenzy," waterfowl, Lost Lagoon, Stanley Park, Vancouver, BC, 1995

Sometimes the soul gets so lonely it tries to break through its silence. The tongue and ear want to handle it, to help it grow, fertilise it. Everything is for the soul's growth. She calls to all the physical and material to help her. This physical body is so short-lived and its only use is to contribute to the growth of the soul. And yet we act as if its sole use was for itself, for its comfort and ease.

HUNDREDS AND THOUSANDS

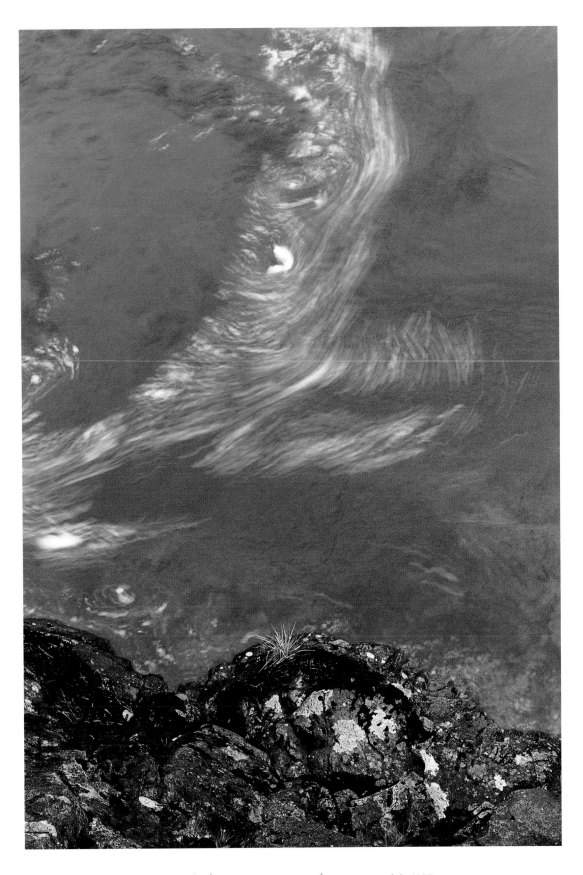

"Surprised," Lynn Canyon, North Vancouver, BC, 1987

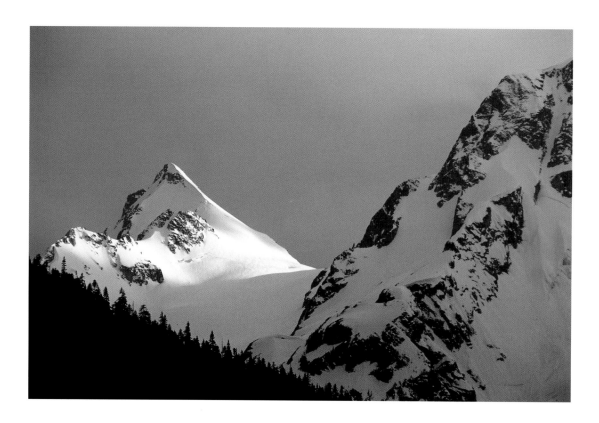

"Evening White," peak near Pemberton, BC, 2000

The settling down in the train with the creatures comfortably arranged for and my eye all agog to absorb scenery. Mountains towering — snow mountains, blue mountains, green mountains, brown mountains, tree-covered, barren rock, cruel mountains with awful waterfalls and chasms and avalanches, tender mountains all shining, spiritual peaks way up among the clouds.

Seton and Anderson lakes, shut in by crushing mountains. A feeling of stifle, of being trapped, of oppression and depression, of foreboding and awe. The train slowly crawling along the lake side on the trestled ledge.

HUNDREDS AND THOUSANDS

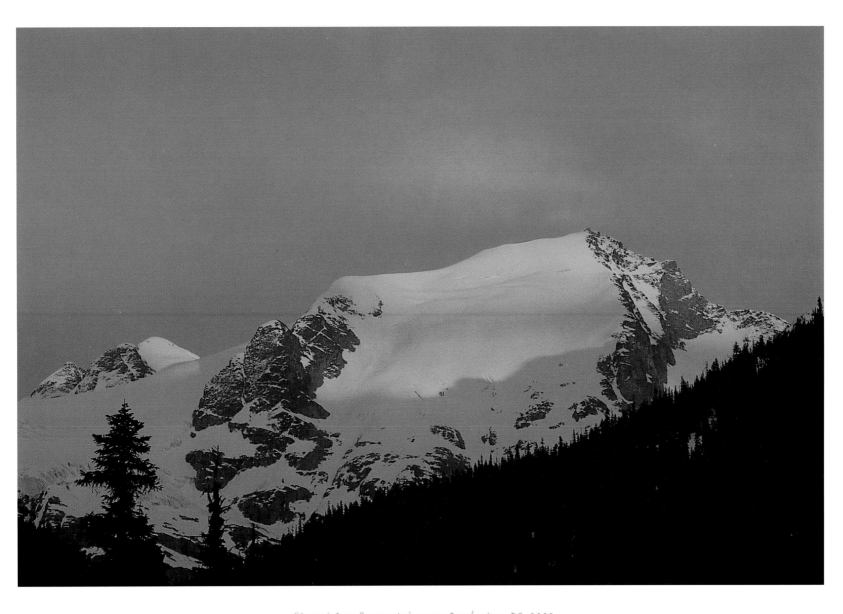

"Sunset Rose," mountain near Pemberton, BC, 2000

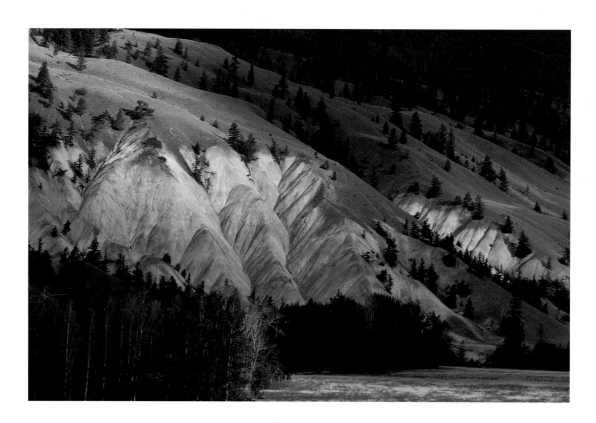

"Shivering Light," mountain near Clinton, BC, 2000

Here we are. Three days at Pemberton have passed already. It is beautiful and exhausting. First day they told me of a walk. Said it was four miles. It proved to be six and I got home exhausted and mad, also late. Today I went up Harvey Mountain, supposed to have one of the grand views. They said it covered all the peaks. I expected a glorious panorama and to walk five miles. I crossed three railway bridges, beastly things, scuttling over them lugging Tantrum and all my gear, counting my steps and reckoning each one aloud to Tantrum. I met two patrollers and stood on edges of track to let them pass. The mountains glorious, tossing splendour and glory from peak to peak.

HUNDREDS AND THOUSANDS

"Mortuary Pole," lodgepole pine north of Lillooet, BC, 2000

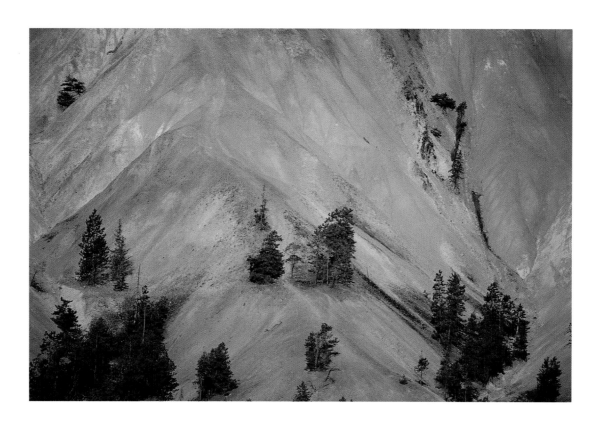

"Rugged Ascent," mountain slope near Clinton, BC, 2000

I want my things to rock and sway with the breath and fluids of life, but there they sit, weak and still, just paint without vitality, without reality, showing that I myself have not swayed and rocked with experiencing when I confronted them. It was but their outer shell; I did not bore into them, reach for their vitals, commune with their God in them. Eye and ear were dull and unreceptive to anything beneath the skin. This great mountain might be a cardboard stage set, not an honest dirt-and-rock solidity of immovableness. What were those infinitesimal trees and grass and shrubs? Pouf, the wind sways them, the fire burns them and they are gone! But the mountain bulk! Ages it has stood thrusting its great peak into the sky, its top in a different world, changed in that high air to a mystic wonder.

HUNDREDS AND THOUSANDS

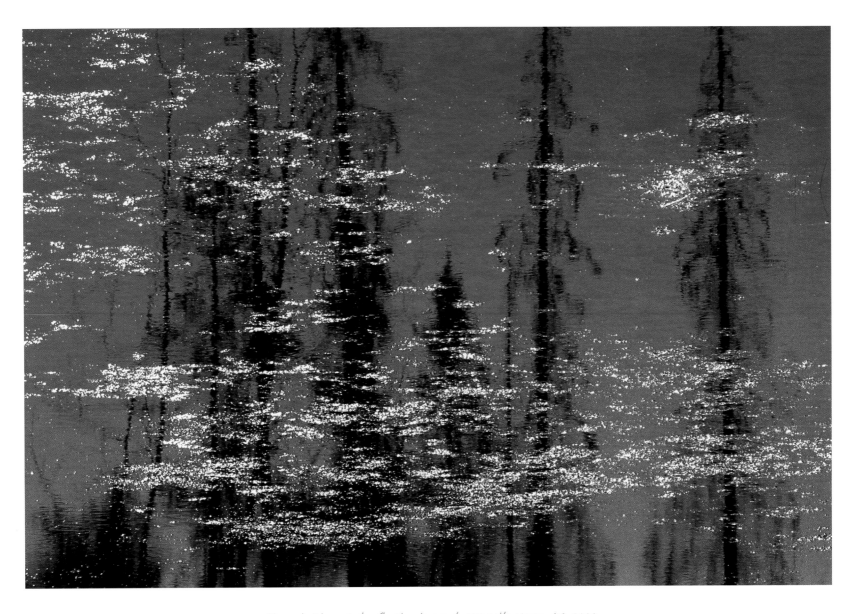

"Reverie," inverted reflection in pond, 100 Mile House, BC, 2000

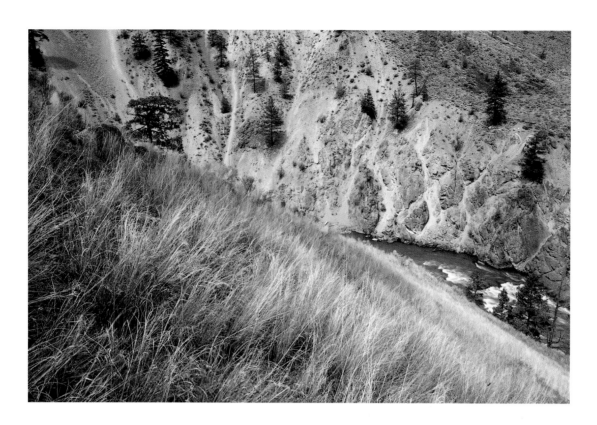

"Rapids on the Lilloet," Cariboo Country, BC, 1984

I can never love Cariboo enough for all she gave to me. Mounted on a cowpony I roamed the land, not knowing where I went — to be alive, going, that was enough. I absorbed the trackless, rolling space, its cattle, its wild life, its shy creatures who wondered why their solitudes should be plagued by men and guns.

"CARIBOO GOLD," GROWING PAINS

"Approaching Storm," Douglas Lake Ranch, Cariboo Country, BC, 1984

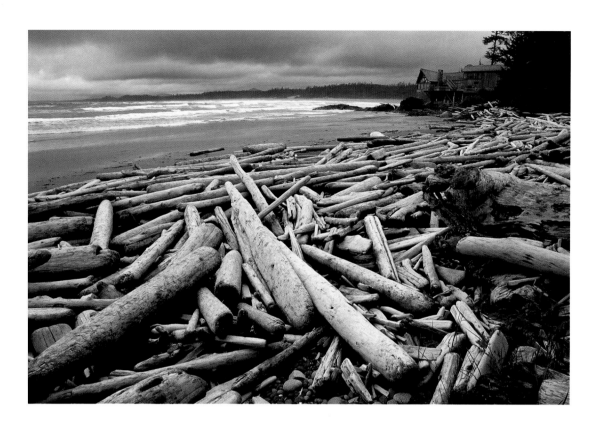

"Drift-laden," Wikininnish Bay, Pacific Rim National Park, BC, 1987

Winter began to nip the Cariboo. The coast called and Vancouver Island, that one step more Western than the West. I went to her, longing yet dreading. Never had her forests looked so solemn, never her mountains so high, never her drift-laden beaches so vast. Oh, the gladness of my West again! Immense Canada! Oh, her Pacific edge, her Western limit! I blessed my luck in being born Western as I climbed the stair of my old barn studio.

"CARIBOO GOLD," GROWING PAINS

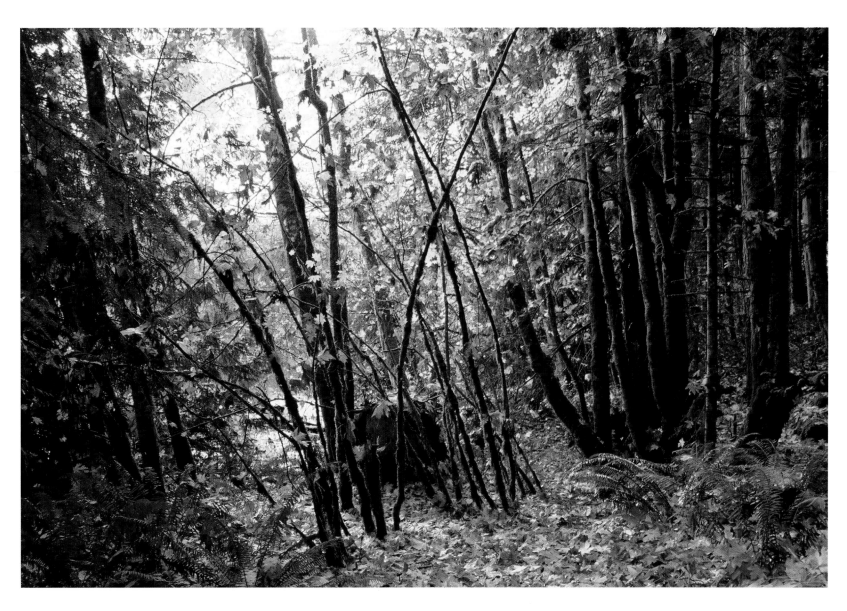

"Autumn Palette," bigleaf maple, swordfern and cedar, Vancouver Island, BC, 1987

"Emily Carr House," *Government Street, Victoria, BC, 2000*

Closer to Home

SPECIAL MOMENTS SHARED

"The garden was a glory of huge poppies and the roses are coming on. Gardens grow so dear to one but I think perhaps we are apt to let them chain us, as we do all our earthly possessions, and encumber us instead of rejoicing us. We do let so much joy slip over our heads and beneath our feet, and let our lives be so full of care. We waste lots of time worrying about our old age that we may never arrive at. We are really awful fools, taking us all round."

HUNDREDS AND THOUSANDS

It seems fitting that my exploration of Victoria and its environs came in large measure at the very end of my twenty-year photographic pursuit of Emily Carr Country. With the exception of a few frivolous times doing impressionistic renditions of flower beds in the well-to-do Oak Bay area, and boat reflections in the protected waters of the marina at Fisherman's Wharf, I had not photographed Victoria at all. The city had become for me a haven, where I took a little time away from the camera, where Adele and I met to put the finishing touches on our workshop plans, and where I would relax and recoup following the sessions at Point-No-Point.

For Emily, Victoria was home for much of her life. It was here on Carr Street (named after her father and later changed to Government Street) that she was born and raised with her four sisters and a brother, and here that she was laid to rest in the Ross Bay Cemetery, only a short distance from her birthplace. Fortunately, the spacious two-storey home has been refurbished in period decor and designated a historic property by

the Historic Sites and Monuments Board of Canada. Just around the corner and a block and a half up the hill is 646 Simcoe St., the House of All Sorts, where she took in "all sorts" of boarders. From there it is a quick two-minute walk up the street to Beacon Hill Park with its commanding view of the Olympic Mountains and the Strait of Juan de Fuca. To explore Emily Carr's favourite haunts is like walking into a storybook of Victoria history. Much still remains, but what is noticeably absent is the secluded clearing where she parked the Elephant, her caravan, on Metchosin Road. The entire area is covered over with the suburbs of Colwood. Emily, of course, would be amazed at the size of Victoria today, but her landmarks still bear the names that she knew when she went out to paint: Cordova Bay, Cadboro Bay, Telegraph Cove, Mount Douglas Park, Esquimalt Lagoon, Albert Head, Beacon Hill Park, and the Empress Hotel. Expensive homes rim the high-tide mark where once there were only waving grasses and wildflowers at Cadboro and Cordova bays, but the beaches are still depositories for driftwood, and some of the old bigleaf maples still offer their protective limbs as guardians of the beach.

It was fun to get out a map of Victoria and plot expeditions to these beauty spots within the city. Adele and Garry Curtis have long opened their home to me, and for virtually all of the Victoria photography Monterey Avenue was my base of operation. Once I had this book in my sights, I was a man with a mission, and Adele too got into the spirit of Emily Carr Country. Each day we loaded our camera gear, lots of water and a lunch, and headed to new locations, some new even to Adele, who has known Victoria for almost thirty years and is always out photographing somewhere. At low tide we aimed for the beaches, at other times concentrated on the parks, and spent entire days at Goldstream, Francis/King Regional Park, and the Gowlland Range in the Highlands District. We explored around Albert Head and Esquimalt Lagoons, and I photographed the same gravel pits that Emily painted and could see from her trailer at one of its locations.

Although it seems tragically inevitable to see that so much of Emily Carr's world has been converted into suburban sprawl, I was also delighted to discover how many of her favourite haunts have been preserved as parks, particularly Beacon Hill, which maintains its grandeur and charm despite its location adjacent to downtown Victoria. Mount Douglas Park also thrives as a natural haven and lookout point, and offers a network of trails through an enchanted forest of giant firs, cedars, oaks, and arbutus. It was here

"Preening," Beacon Hill Park, Victoria, BC, 2000

that I chanced upon a stray shaft of light that had penetrated the deep forest to languish in a reflecting pool. As often happens, my entry with tripod and camera seemed to disturb the alchemy of the pond. The delicate light, like a forest spirit, hovered only for an instant, then flitted away. No doubt the openness and elevated awareness, even the exaggerated feelings of fragility and interconnectedness that followed me into the woods that day were no strangers to Emily when she set out to paint the mystical forest.

Beacon Hill Park draws people from near and far. It holds something for everyone — sports fields, lawn bowling, a children's zoo, conservatory, scenic lookout, duck ponds, ornamental trees, wild areas, bird sanctuary, kids' playground, walking and hiking paths, and great stretches of room to picnic or relax. Though the offering of activities has increased dramatically in recent years, Beacon Hill still sports the wild, unkempt topknot it did in Emily's day, as an exuberant little girl in the 1870s and matronly artist of the early 1940s.

I think my reaction to the park was a lot like Emily's in spite of the time lapse. I loved it as a sanctuary in which to relax and a place where I could feel grateful just to be alive. There is a buoyant energy that surges with the wind on the higher ground. No wonder it was the place Emily would go for inspiration. I, too, went there to express myself artistically, but initially found the lower reaches a little too tame. Then, as I explored with the camera, I began to have a bit of fun with Beacon Hill's domestic side. I particularly loved the peacocks, because they reminded me of Emily's affinity for all animals and how readily she communicated with them. Like Emily, I enjoyed the waterfowl as they motored silently through the miniature lakes, their pristine V's carving into the reflected azaleas. Emily would paint, squatted down on her camp stool, and I would photograph, hunched behind my tripod, but I suspect Emily, like me, would have felt rebellion brewing against the manicured gardens, and longed for wilder places. "Go out there into the glory of the woods," she wrote. "See God in every particle of them expressing glory and strength and power, tenderness and protection. Know that they are God expressing God made manifest."

Making the rounds in Victoria felt like drawing a circle around Emily's entire life. The following pages cover the entire gamut from her birthplace to her grave. The making of these pictures gave me time to ponder. Not far from the stone bridge where I was photographing the ducks, I flopped down on a bench, leaned the tripod against

my knee, closed my eyes, and savoured the delicious afternoon sun. All was perfect and whole and good in Emily Carr Country. The job was done. Knowing that my mission was accomplished brought back a flood of memories of many outings and precious moments over the years. Photographing with diligence and purpose did for me what I knew Emily had done for countless souls — it filled me with the assurance that I was precisely where I was meant to be, doing exactly what I was meant to do. Hers was the unwavering knowledge of the divinity within, the part that connected so often and so readily to the entire universe. She knew what each of us knows but too often is afraid to acknowledge — that when we follow our dream, truly listen to the inaudible whisperings of our soul, all else will eventually fall into place and all other pursuits will pale in comparison.

Towards the end of her life, Emily was asked to recount the outstanding events for her. "Outstanding events! — work and more work! The most outstanding seems to me that buying an old caravan trailer which I had towed to out-of-the-way corners and where I sat self-contained with dogs, monkey and work — Walt Whitman and others on the shelf — writing in the long, dark evenings after painting — loving everything terrifically. In later years my work had some praise and some successes, but the outstanding event to me was the *doing* which I am still at. Don't pickle me away as a 'done.'"

"Tremendous World," azaleas, Beacon Hill Park, Victoria, BC, 2000

Between our lily field and Beacon Hill Park there was nothing but a black, tarred fence. From the bag that carried Mother's sewing and our picnic, she took a big key and fitted it into the padlock. The binding-chain fell away from the pickets. I stepped with Mother beyond the confines of our very fenced childhood. Pickets and snake fences had always separated us from the tremendous world. Beacon Hill Park was just as it had always been from the beginning of time, not cleared, not trimmed. Mother and I squeezed through a crack in its greenery; bushes whacked against our push.

GROWING PAINS

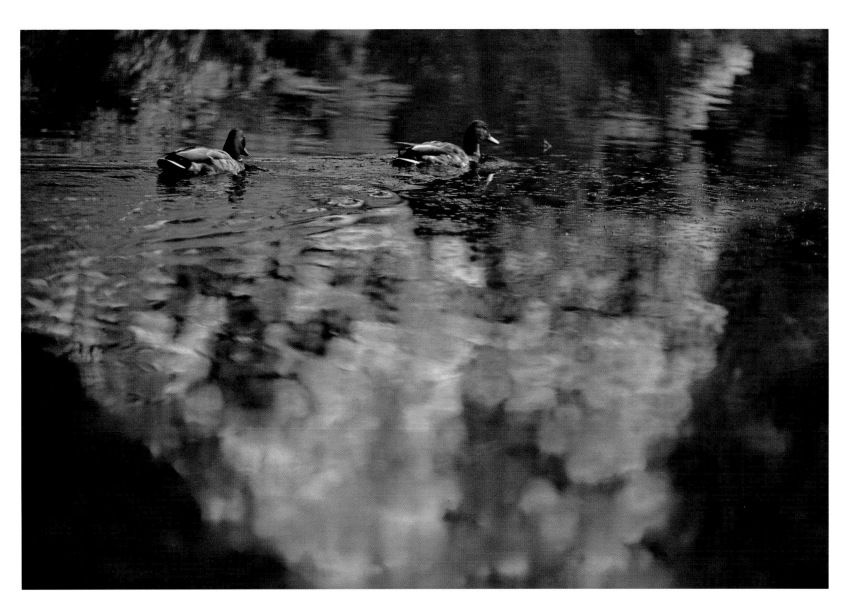

"Upon Reflection," Beacon Hill Park, Victoria, BC, 2000

I knew now why we were never allowed to go into Beacon Hill swamp to gather spring flowers: it was not on account of the mud at all, but because of this nightingale monster.

"I shall never, never go into Beacon Hill Park again," I said to myself. "I won't let on I'm scared but when we go for a walk I shall say, 'let's go to the beach, it's much nicer than the Park.'"

I thought, "Perhaps she comes to the Park like the birds to nest in the Spring. perhaps the Park might be safe in winter when the Monster went south."

I heard Father shoot the front-door bolt and the grown-ups coming up the stair. As the candles flickered past our door I whispered, "Mother!"

She came to me.

"Why are you not asleep?"

"Mother, how big is a nightingale?"

"Nightingales are small birds, we do not have them in Victoria."

Birds! — None in Victoria!

"But Father said —"

"That was just a joke, calling our little green frogs nightingales. Go to sleep, child."

Dear little hopping frogs! — I slept.

THE BOOK OF SMALL

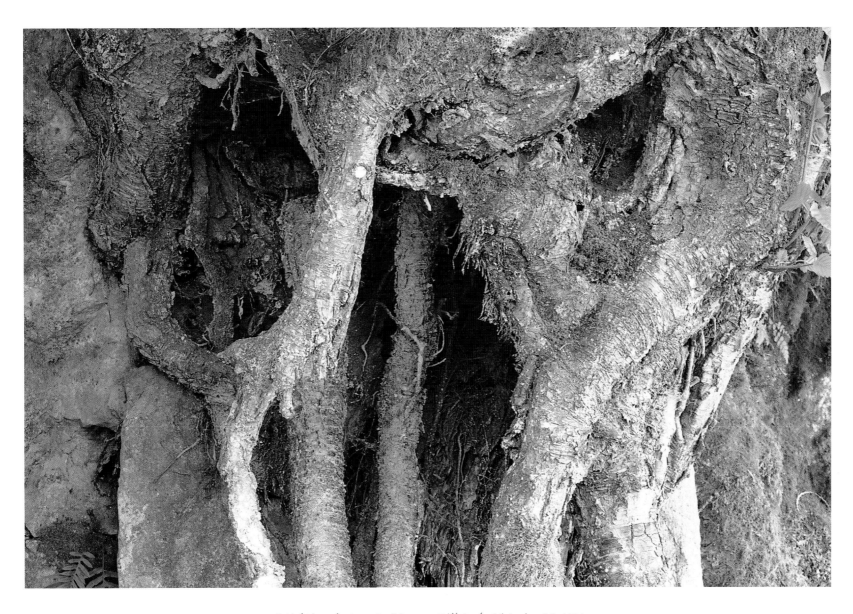

"Nightingale Monster," Beacon Hill Park, Victoria, BC, 1998

"Flower Study 1," Oak Bay, Victoria, BC, 1998

I walked to the Empress Hotel, straight into the Conservatory, passing through the empty lounge and corridors. I suppose most of the guests were still in bed. Boys with dust pans looked here and there for possible dirt. The Conservatory was empty of humans – just the flowers, and they were at worship and let me join them. Cyclamen, pink, red, purple-red, rose; prunella; little pink begonia; pots of green . . .

It was very holy in there. They were worshipping as hard as they knew how, fulfilling the job God gave them to do. The stream of life, God's life, was passing through them. You could feel their growth and their praise rising up to God and singing, not as we humans sing, but glorifying in their own way, their faces pure and lovely, growing, fulfilling, every moment.

THE BOOK OF SMALL

"Flower Study 2," Oak Bay, Victoria, BC, 1998

"Flower Study 3," Oak Bay, Victoria, BC, 1998

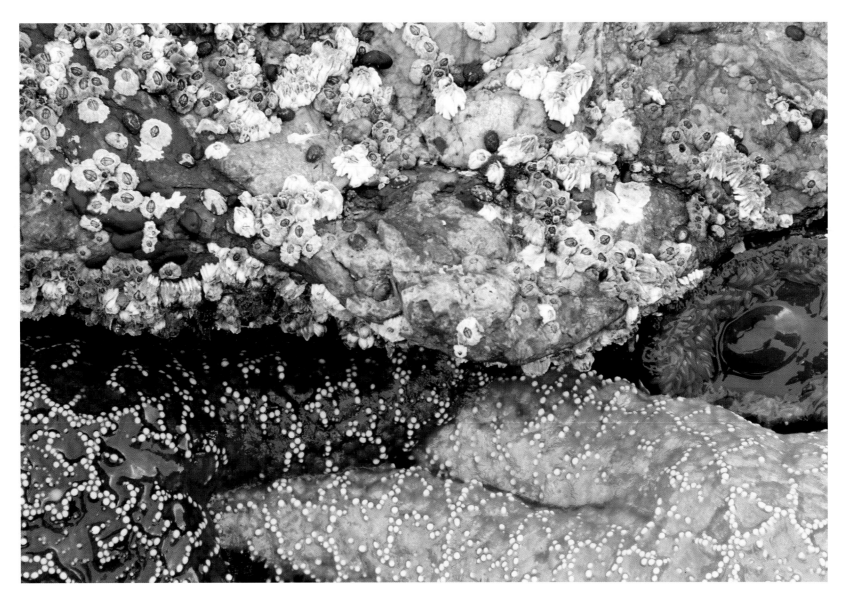

"Snuggled In," sea stars, anemone, and barnacles, 1985

The long summer days passed and the crisp autumn ones, and every day the peacock and I screeched our greeting and spent long companionable hours. Then one day I kissed his crest, put him out, and closed the window. That night I went abroad.

In my absence a parson occupied the studio and wrote sermons there. He closed the wall-cracks with newspaper to keep out the singing wind, and caught the mice in traps.

"What of my peacock?" I wrote home.

"He came once, the morning after you left. Since then he has not come at all," was the reply. "We see him strutting in the park, delighted with admiration. He has doubtless forgotten you," they added.

I was absent for over five years. . . .

I ran up the rickety barn stairs to the studio. Phew! How musty and "sermony" it smelt! . . . Everything was drab: the cherry tree, old, past bearing, had been cut down. I thought of the peacock. "Gone where good peacocks go," I sighed, and wondered where that was.

Next morning I was busy on the floor with a pail of suds.

Hark! In my rush the suds were knocked over and tricked through the floor onto the back of the patient cow below. I leaned from the window and screeched that unwritable screech. It was answered instantly. The peacock was hurrying through the garden, unmindful of his tail, which swept the leaves and dirt. Hurrying, hurrying, not to the mirror — he could have had that all these years — but to me.

"Oh, peacock! Now I know that if they did turn you inside out your loyal heart would be lovelier than your feathers!"

THE HEART OF A PEACOCK

"Loyal Heart," peacock displaying tail plumage, 1986

"Egg Yolks," multiple exposure on broom, Witty's Lagoon, Mechosin, BC, 1998

I have been in among the broom on Beacon Hill sketching. It is difficult sometimes to separate its yellow glory from the yolks of countless eggs. The smell gets right inside of you. It and the blackbirds' song permeate your whole you. If one could only approach a subject like that, by drinking it up to the sky! I think it is such a glory.

HUNDREDS AND THOUSANDS

"Yellow Glory," multiple exposure on broom, Witty's Lagoon, Mechosin, BC, 1998

"House of All Sorts," 646 Simcoe St., Victoria, BC, 2000

I feel old, old, old and stiff and tired, except when I paint; then I'm no age. At night, folded close in the blackness among the trees it was not lonesome by the roadside in the old van. In town it is different, in the great, still house. Empty rooms are around, except those filled with impossibles — souls that never touch mine, greater strangers than the strange; no common interests or doings or thoughts; thin partitions dividing our bodies, immense adamant walls separating our souls.

HUNDREDS AND THOUSANDS

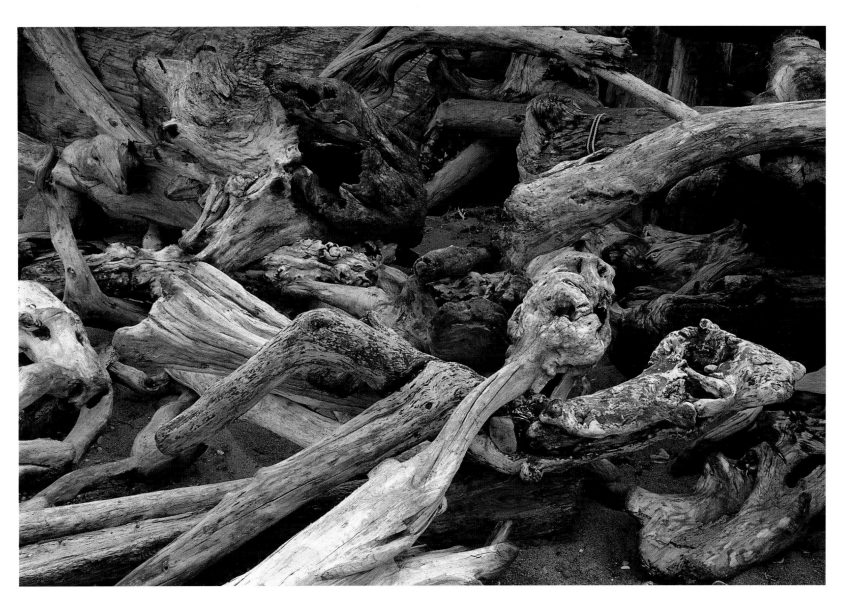

"All Sorts," driftwood, Cordova Bay, Victoria, BC, 2000

"Barnacles," Cadboro Bay, Victoria, BC, 2000

Empty yourself, come to the day's work free, open, with no preconceived ideas, no set rule of action, open and willing to be led, receptive and obedient, calm and still, unhurried and unworried over the outcome, only sincere and alert for promptings.

HUNDREDS AND THOUSANDS

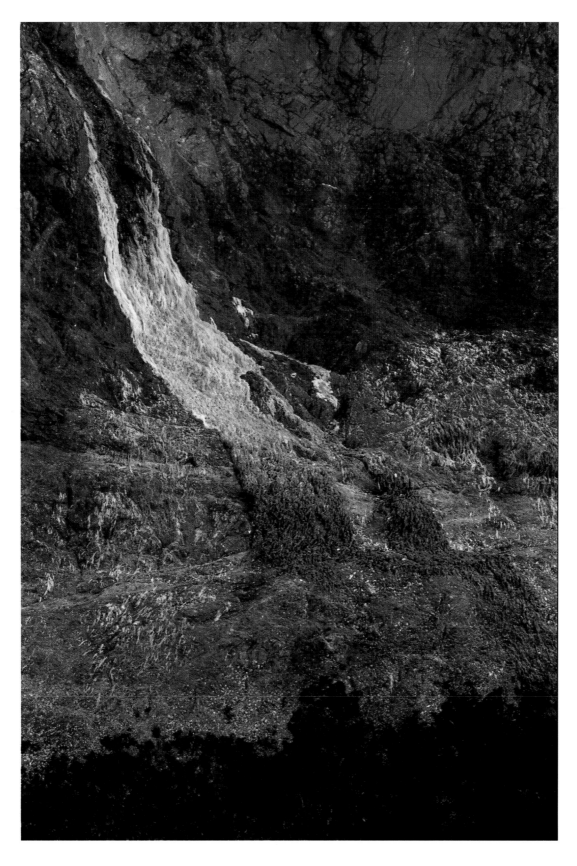

"Solitude," algae on cliff, Mount Douglas Park, Victoria, BC, 2000

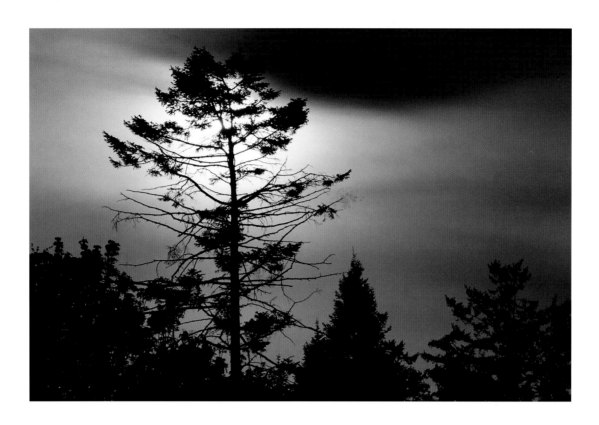

"Nightfall," Telegraph Cove, Victoria, BC, 2000

Today everything is sullen and black. The wind slams things, and the trees are provoked at having their petticoats turned over their heads. The under sides have a pale, wilted look like a faded garment that has been turned back again. Every moment it seems as if the sullen sky were going to leak its waters, as it has already leaked its gloom on the earth. I have waited all morning for it to happen; now I shall defy it.

HUNDREDS AND THOUSANDS

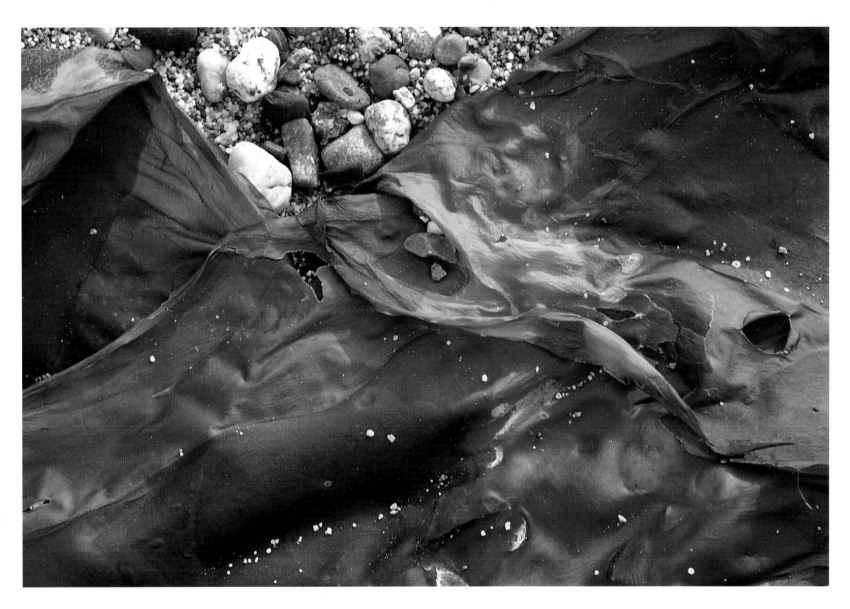

"Dried Kelp," Telegraph Cove, Victoria, BC, 2000

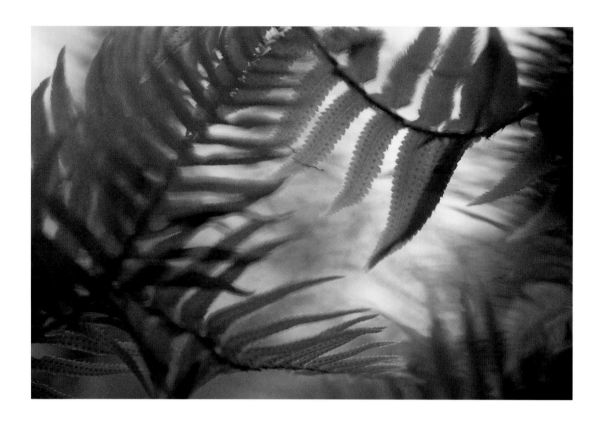

Seventy years had maimed me, loggers had maimed the clearing. I could no longer scramble over great logs nor break my way through networks of brambles, creep under bushes and drown myself crown-high in lush, young growth. I had to be taken out, set down and called for, which was a nuisance, but I got immense delight in just being there, in the quiet wood, nobody for company but Spring.

Though everything was so still, you were aware of tremendous forces of growth pounding through the clearing, aware of sap gushing in every leaf, of push, push, push, the bursting of buds, the creeping of vines. Everything expanding every minute but doing it so subtly you did not actually see anything happen.

GROWING PAINS

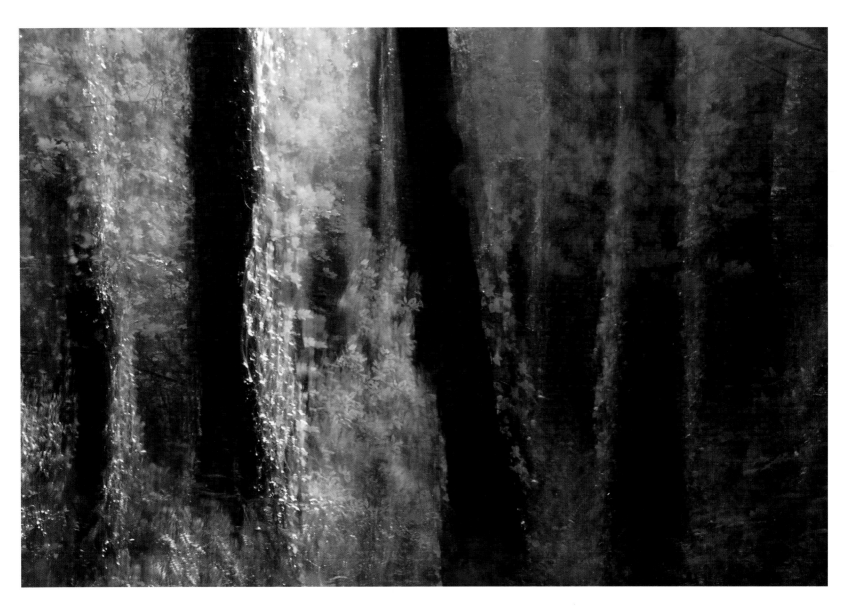

"Dripping Light," fir and maples, Mount Douglas Park, Victoria, BC, 2000

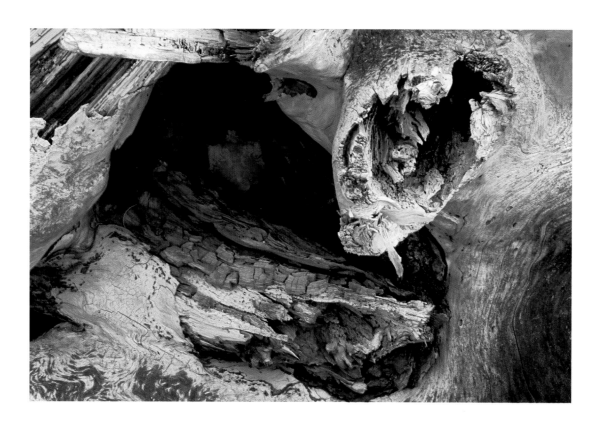

"Seclusion," sun bleached drift log, Glencoe Cove, Victoria, BC, 2000

Tomorrow there is to be a fool fuss presenting my picture "Kispiox" to the government. I'm not going to the affair in the building but have to appear at a pink tea at the Empress. . . . I wonder why being confronted with my work in the face of the public always embarrasses and reproaches me so terribly. Is it because there is dishonesty or lack of sincerity in the work, something that doesn't ring true, a lack of integrity in my presentation of the subject, or is it a sort of reaction arising from the perpetual snubbing of my work in my younger days, the days after I went away and had broken loose from the old photographic, pretty-picture work? Gee whiz, how those snubs and titters hurt in those days! I don't care half so much now, and yet those old scars are still tender after all these years.

HUNDREDS AND THOUSANDS

"Whimsy," close-up of camas, Uplands Park, Victoria, BC, 2000

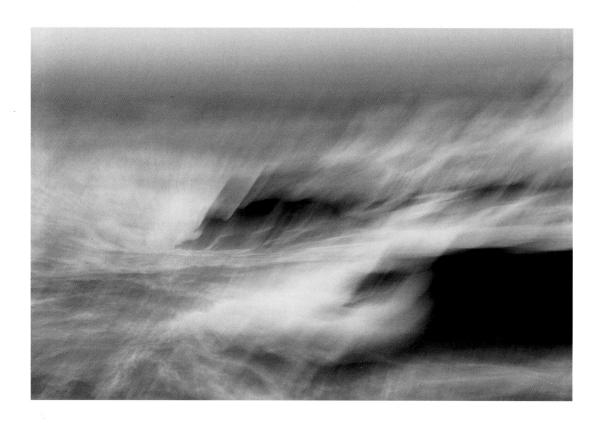

"Storm at Sea," camera motion on surf, 1987

I wonder will I ever attain the "serene throb," that superlative something coming from perfect mechanics with a pure and complete thought behind it, where the thing breathes and you hold your breath as if you had spent it all, had poured it into the creation. Sometimes when you are working, part of you seems chained like a bird I saw in England once, tied by a thread on its leg to a bush. It fluttered terribly, and I went to see what was wrong. The string cut through the leg as I came and the bird fluttered harder. The leg was left on the bush with the string, and the bird was free. Has one always to lose something, a very part of them, to gain freedom? Perhaps death is like that, the soul tearing itself free of the body.

HUNDREDS AND THOUSANDS

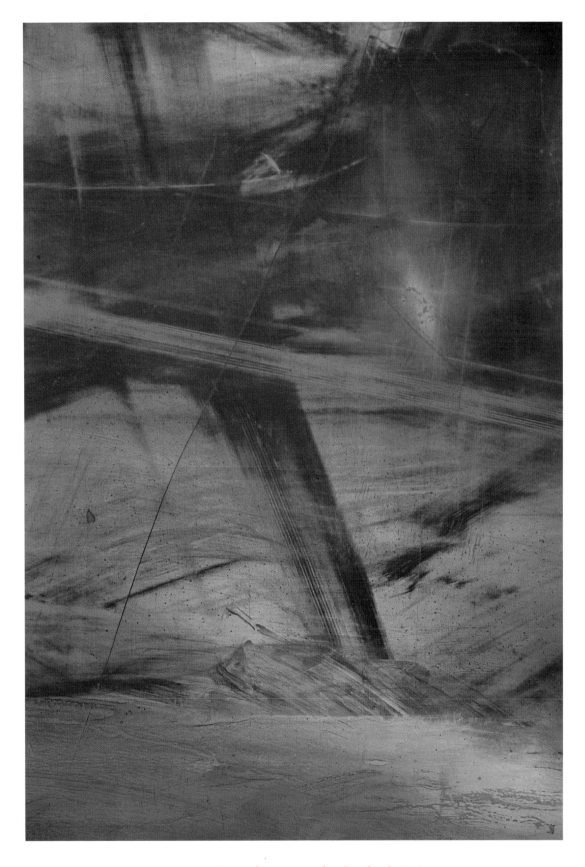

"Tempest," streaks on copper fireplace hood, 2000

Artist, Poet, Singer, where are you going today?
Searching, struggling, striving to find the way.

Artist, Poet, Singer, tell me what is your goal?
By listening, learning, expressing, to find the soul.

Artist, Poet, Singer, what are you after today —
Blindly, dimly, dumbly trying to say?

Aye, Artist, Poet, Singer, that is your job,
Learning the soul's language, trying to express your God.

HUNDREDS AND THOUSANDS